THE WOMEN WHO WHO CHANGED ART FOREVER

FEMINIST ART – THE GRAPHIC NOVEL

First published in Great Britain in 2021 by
Laurence King Publishing
an imprint of The Orion Publishing Group Ltd
Carmelite House, 50 Victoria Embankment
London EC4Y 0DZ

An Hachette UK Company

1 3 5 7 9 10 8 6 4 2

Original edition *Feminist Art*
published in Italian by Centauria

© Centauria srl 2020
Text © Valentina Grande
Illustrations © Eva Rossetti
Graphic design by Studio Ram

A CIP catalogue record for this book is
available from the British Library.

ISBN 978 1 91394 700 2

Printed in China by C&C Offset Printing Co., Ltd.

Laurence King Publishing is committed to ethical
and sustainable production. We are proud participants in
The Book Chain Project® bookchainproject.com

www.laurenceking.com
www.orionbooks.co.uk

This book has been translated thanks to a translation
grant awarded by the Italian Ministry of Foreign Affairs
and International Cooperation.

Questo libro è stato tradotto grazie a un contributo alla
traduzione assegnato dal Ministero degli Affari Esteri e
della Cooperazione Internazionale italiano.

English translation from the original Italian by Edward Fortes

THE WOMEN WHO CHANGED ART FOREVER

FEMINIST ART – THE GRAPHIC NOVEL

VALENTINA GRANDE
AND EVA ROSSETTI

Translation by Edward Fortes

Laurence King Publishing

CONTENTS

JUDY CHICAGO
Pride in the Body

FAITH RINGGOLD
A Voice for African-American Women

ANA MENDIETA
Pushing the Boundaries of Identity

GUERRILLA GIRLS
Storming the Male-Dominated Museum

Can a single book tell the story of the feminist art movement?

No. As a screenwriter, I won't claim to be able to encapsulate what feminist art was, particularly when a definition of feminism is the starting point: there isn't one feminism, but many. One of the aims of this book is to shed some light on the important, overriding themes of these feminisms for the reader.

Feminist art is not art made by women; it is not a movement that differs by virtue of technical choices or innovative forms, but an artistic and political movement in which the artists were activists for women's rights and used art as their means of struggle.

There are great artists who never saw themselves as feminists, or eschewed the definition despite having produced pieces with clear feminist themes as part of their body of work. I have favoured those who declared themselves to be feminists and made it a hallmark of their style. By dedicating their whole output to the subject, they hoped to give voice to all other women artists, as well as to figures who were vital for the movement, including, for example: Gina Pane, Regina José Galindo and Hannah Wilke, who do not feature here for an obvious lack of space.

The artists whose stories I have told let us reflect on four different aspects. Judy Chicago was one of the movement's pioneers: she saw it emerge and worked on the reappropriation of language. Hers was a political choice to name and represent what were, and unfortunately remain, taboos: blood, the vagina, sanitary towels. Her activism underwent a turning point in Fresno, when she worked with a group of female students who, even before they learned about artistic technique, needed to be empowered to work on their abilities. These were the movement's first, tentative steps. Chicago started from the vagina, which is a powerful symbol of female identity.

As an African-American woman, Faith Ringgold, the second artist, reflected on the limits of 1970s feminism as a movement for middle-class white women, which did not include the question of Civil Rights within its struggle – an argument also put forward by Ana Mendieta. Black women were thus fighting on two fronts: both as women and as Black women. Often, as happened to Ringgold, they came up against a wall within their own communities because the men felt threatened.

Ana Mendieta, a Cuban exile in the United States, turned her gaze towards notions of

origin and identity. In her work, Mendieta seeks a return not to a homeland but rather to the origin of all things: the myth of the Great Mother, the goddess who was the origin, end and becoming of every living being. At the same time, through her performance work, Mendieta also focused her practice on identity. She explored the range of possible 'I's contained within every person. At that time, the field of Gender Studies was articulating how gender was nothing more than a performative repetition of a series of actions associated with the male or female. Female artists make these instances their own, thus enabling those watching to participate in the myriad possibilities inherent in every one of us. Mendieta died in tragic circumstances in 1985, when she fell from the balcony of her 34th-floor apartment. Her husband, the sculptor Carl Andre, was put on trial for murder after a neighbour testified to having heard the couple arguing, and subsequently heard Mendieta's voice shouting, 'No' before the fall. Following two trials the husband was acquitted owing to a lack of evidence.The story split the art world between defence and accusations, and even today there are still protests at every Andre exhibition – both to boycott his work but also to remember Ana. We decided not to include the circumstances of her death in the story you're about to read, only her life, and not to mention Andre by name. Regardless of what really happened, Ana Mendieta must exist as an artist.

The book's final chapter closes with a statement by the Guerrilla Girls, who represent the most all-embracing conclusion to this journey. They are feminist artists with no specific identity or geographical location; they stand for all women, those who have been forgotten in the past, and those fighting today to ensure that culture is for – and represents – all people and all genders. They are intersectional feminists: they call out the injustices perpetrated in the art world not only towards women, but also towards Black, gay, lesbian and trans people, and all those who are oppressed by the privileges of patriarchal power.

The lowest rung of the privilege ladder would be reserved for a disabled, Black, trans, lesbian migrant woman. Does such a person exist? Of course they do, but they're invisible.

The Guerrilla Girls and all feminist artists work to ensure that person can represent themselves – and no one need wonder whether they exist anymore.

Valentina Grande

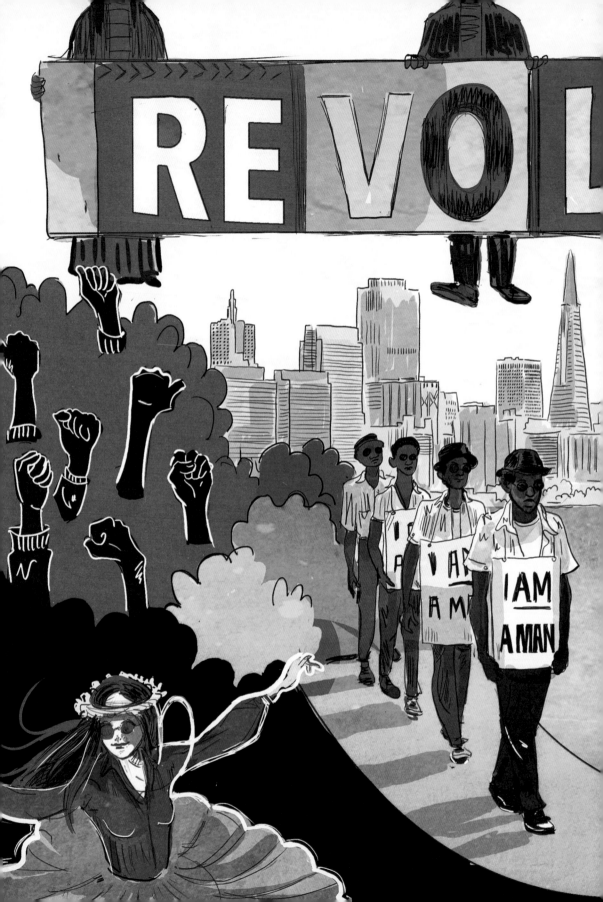

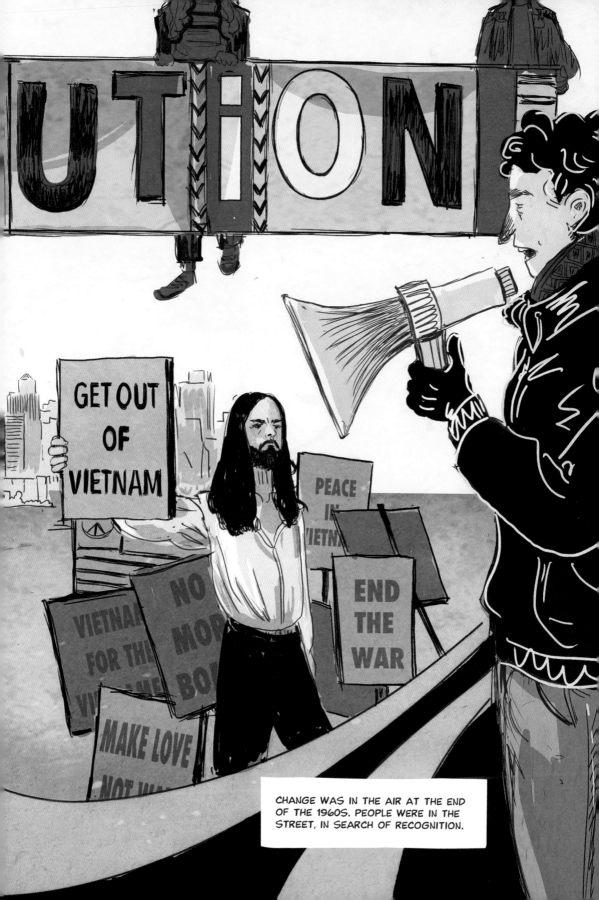

CHANGE WAS IN THE AIR AT THE END OF THE 1960S. PEOPLE WERE IN THE STREET, IN SEARCH OF RECOGNITION.

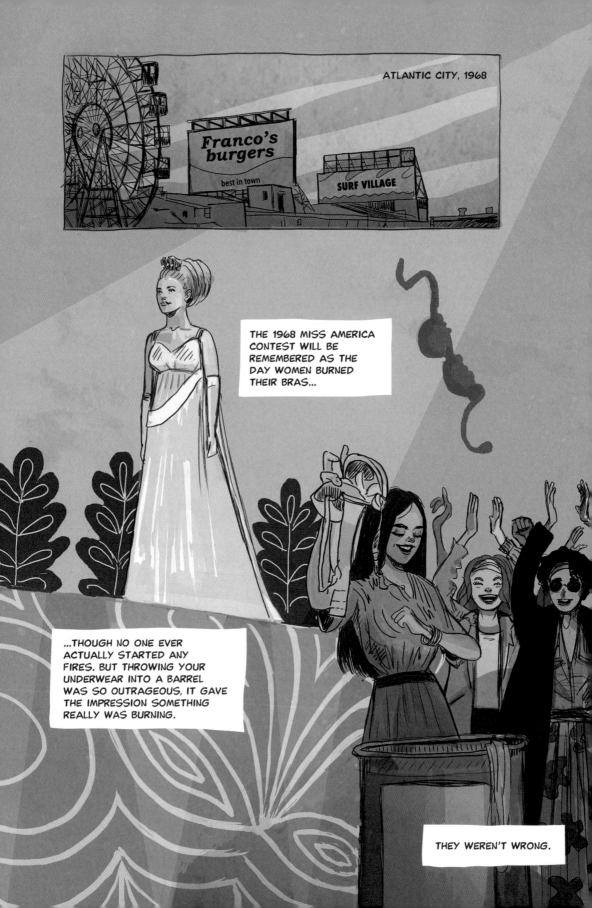

PEOPLE KEPT CUTTING...

...AND I SAT THERE, LIKE A STONE...

...BUT NO ONE COULD KNOW HOW MUCH STRENGTH THERE WAS INSIDE THE STONE.

YOKO ONO, ARTIST

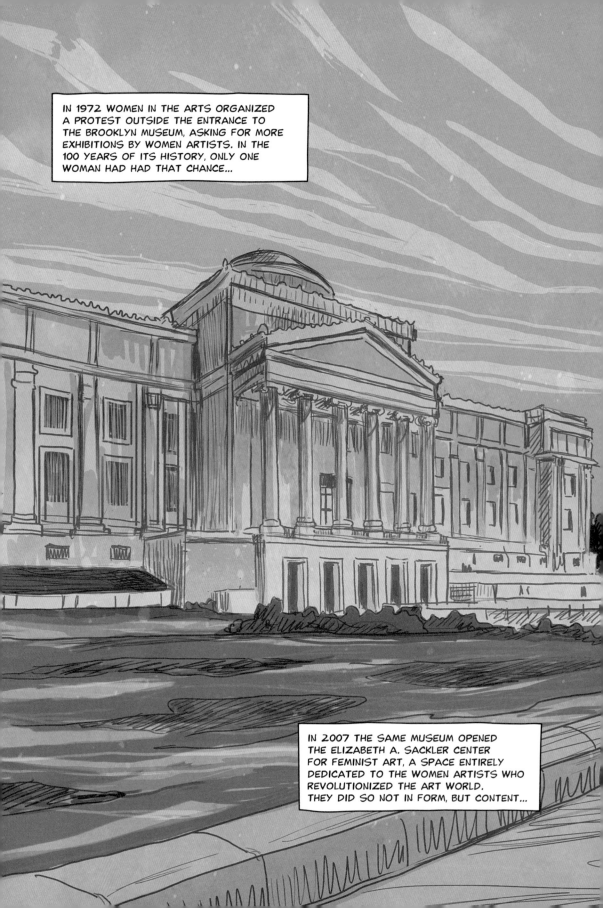

IN 1972 WOMEN IN THE ARTS ORGANIZED A PROTEST OUTSIDE THE ENTRANCE TO THE BROOKLYN MUSEUM, ASKING FOR MORE EXHIBITIONS BY WOMEN ARTISTS. IN THE 100 YEARS OF ITS HISTORY, ONLY ONE WOMAN HAD HAD THAT CHANCE...

IN 2007 THE SAME MUSEUM OPENED THE ELIZABETH A. SACKLER CENTER FOR FEMINIST ART, A SPACE ENTIRELY DEDICATED TO THE WOMEN ARTISTS WHO REVOLUTIONIZED THE ART WORLD. THEY DID SO NOT IN FORM, BUT CONTENT...

...CREATING A RIFT IN THE DOMINANT CULTURE AND OPENING IT UP TO WOMEN'S PERSPECTIVES, DISREGARDING A HISTORY THAT WASN'T THEIR OWN.

MY POWER AS A WOMAN COMES FROM DEFINING MYSELF AND NOT BEING DEFINED BY OTHER PEOPLE.

AUDRE LORDE, WRITER AND FEMINIST ACTIVIST

JUDY CHICAGO

Pride in the Body

I STARTED DRAWING WHEN I WAS 3.

MY PARENTS WERE VICTIMS OF MCCARTHYIST
ANTICOMMUNISM. ONE DAY A MAN FORCED HIS WAY
INTO OUR HOUSE. YEARS LATER I DISCOVERED HE WAS
AN FBI AGENT.

I'LL ALWAYS BE GRATEFUL TO MY MOTHER FOR NEVER
HAVING ASKED ME TO GIVE UP ON MY DREAMS TO MAKE
HER LIFE EASIER.

I WANTED TO BE AN ARTIST, BUT I REALIZED MY GENDER
WAS A BARRIER TO BECOMING ONE.

MY DAD LOST HIS JOB BECAUSE OF HIS POLITICAL ACTIVISM;
THEN HE GOT SICK AND DIED OF AN ULCER.

I HAD MY FIRST ORGASM AT 16 WITH TOMMY, ON NEW
YEAR'S EVE. I THOUGHT I WAS A WHORE.

MY HUSBAND JERRY DIED IN A CAR ACCIDENT.
I WENT TO THE BEACH TO FEEL THE WIND, THE SAND
AND THE SOUND OF THE WAVES, AND AMID THE PAIN
I UNDERSTOOD THAT I WAS THE ONLY THING I COULD
RELY ON BECAUSE EVERYTHING IS UNCERTAIN.

I HAVE BEEN ACCUSED OF MIXING POLITICS AND ART
FOR MY OWN BENEFIT.

I'VE KNOWN MEN WHO ONLY WANTED TO GET ME INTO BED,
MEN WHO EXPECTED CARE AND ATTENTION, AND MEN WHO
WERE SCARED BY MY WORK.

I CHANGED MY LAST NAME TO CHICAGO LIKE THE
BLACK PANTHERS DID, BECAUSE I WANTED TO BE
IN CONTROL OF MY OWN LIFE; I WANTED TO CHOOSE
MY OWN NAME.

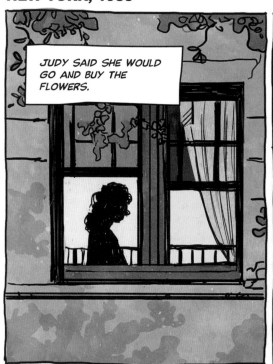

JUDY SAID SHE WOULD GO AND BUY THE FLOWERS.

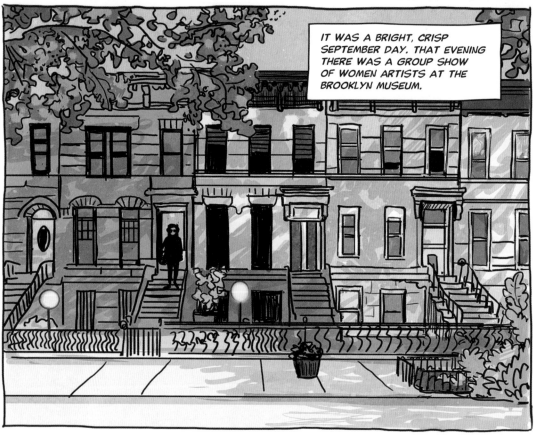

IT WAS A BRIGHT, CRISP SEPTEMBER DAY. THAT EVENING THERE WAS A GROUP SHOW OF WOMEN ARTISTS AT THE BROOKLYN MUSEUM.

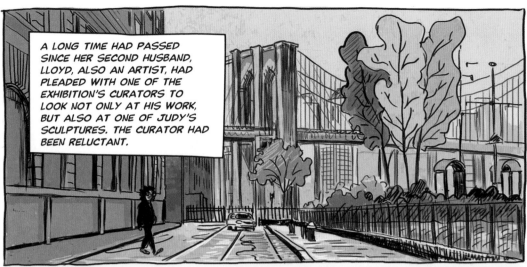

A LONG TIME HAD PASSED SINCE HER SECOND HUSBAND, LLOYD, ALSO AN ARTIST, HAD PLEADED WITH ONE OF THE EXHIBITION'S CURATORS TO LOOK NOT ONLY AT HIS WORK, BUT ALSO AT ONE OF JUDY'S SCULPTURES. THE CURATOR HAD BEEN RELUCTANT.

BECAUSE – YES – SHE WAS A WOMAN.

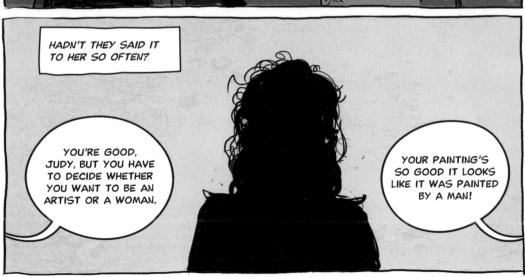

HADN'T THEY SAID IT TO HER SO OFTEN?

YOU'RE GOOD, JUDY, BUT YOU HAVE TO DECIDE WHETHER YOU WANT TO BE AN ARTIST OR A WOMAN.

YOUR PAINTING'S SO GOOD IT LOOKS LIKE IT WAS PAINTED BY A MAN!

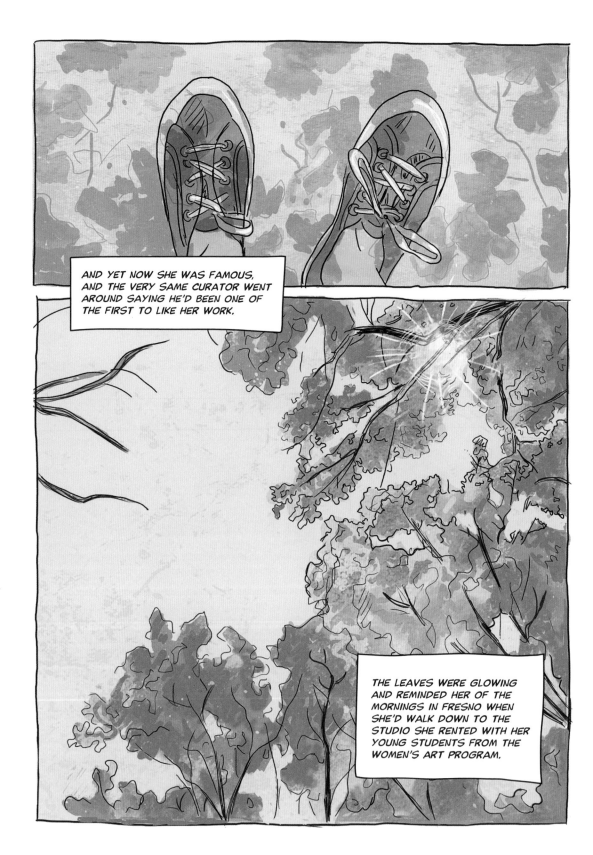

AND YET NOW SHE WAS FAMOUS, AND THE VERY SAME CURATOR WENT AROUND SAYING HE'D BEEN ONE OF THE FIRST TO LIKE HER WORK.

THE LEAVES WERE GLOWING AND REMINDED HER OF THE MORNINGS IN FRESNO WHEN SHE'D WALK DOWN TO THE STUDIO SHE RENTED WITH HER YOUNG STUDENTS FROM THE WOMEN'S ART PROGRAM.

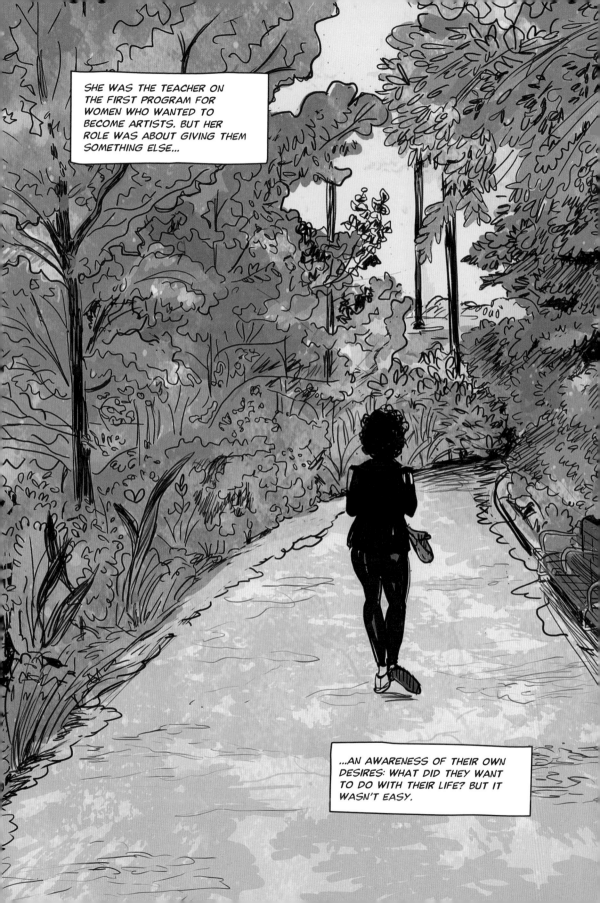

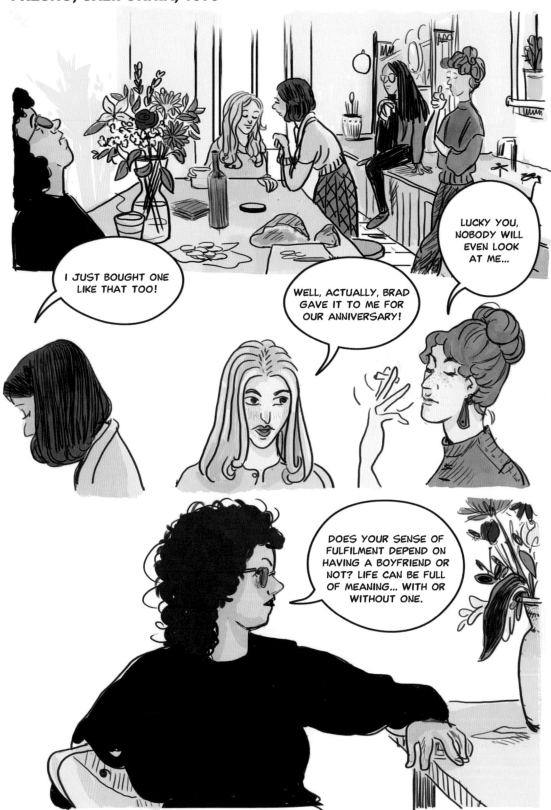

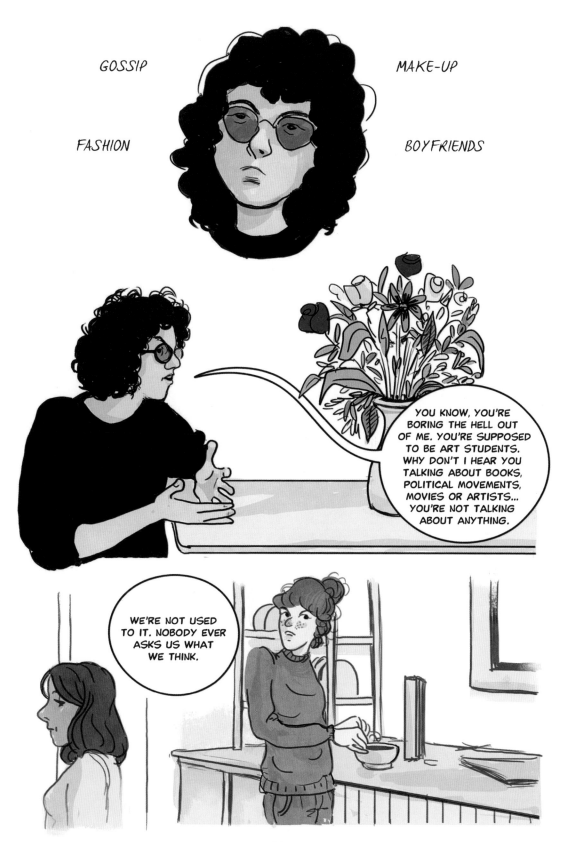

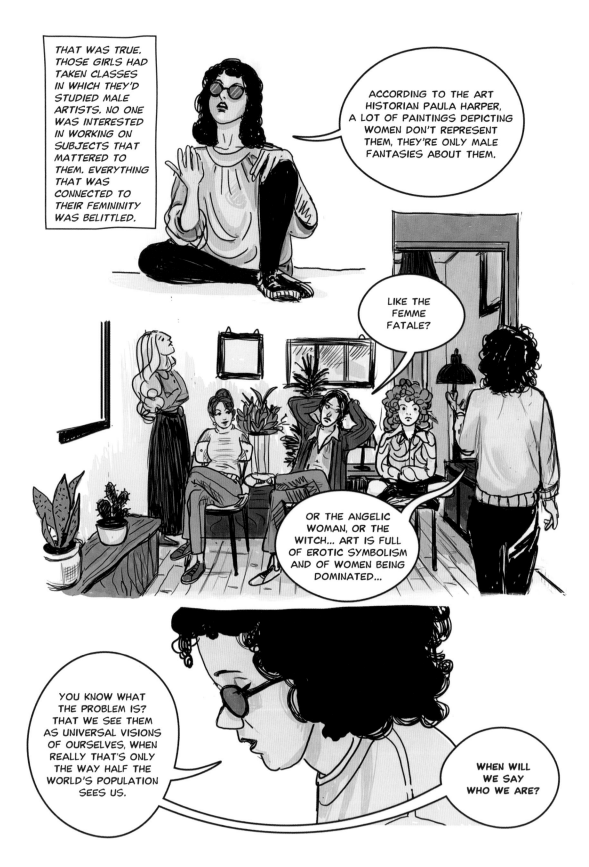

SHE THOUGHT BACK TO THOSE DAYS IN FRESNO, TO THE KIND OF QUESTIONS THAT BROADEN HORIZONS AND DEMAND ANSWERS...

SHE CAME TO THE FRONT OF A FLORIST'S AND HER THOUGHTS TURNED TO THE LONG-STEMMED FLOWERS. SHE LOVED THEM; THEY WERE IN THE STUNNING PICTURES PAINTED BY GEORGIA O'KEEFFE...

...WHOSE WORK HAD INSPIRED THE ICONOGRAPHY OF THE PIECE THAT MADE HER NAME, THE DINNER PARTY...

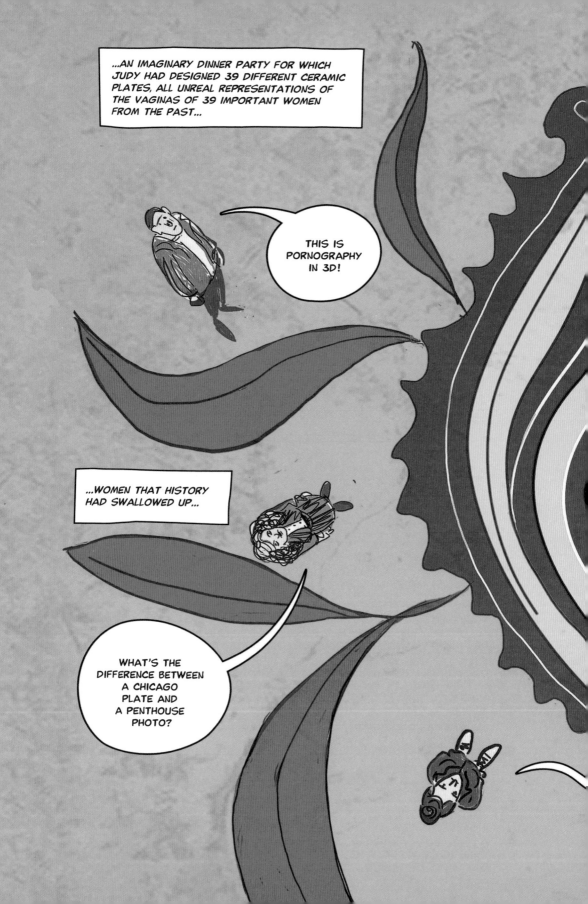

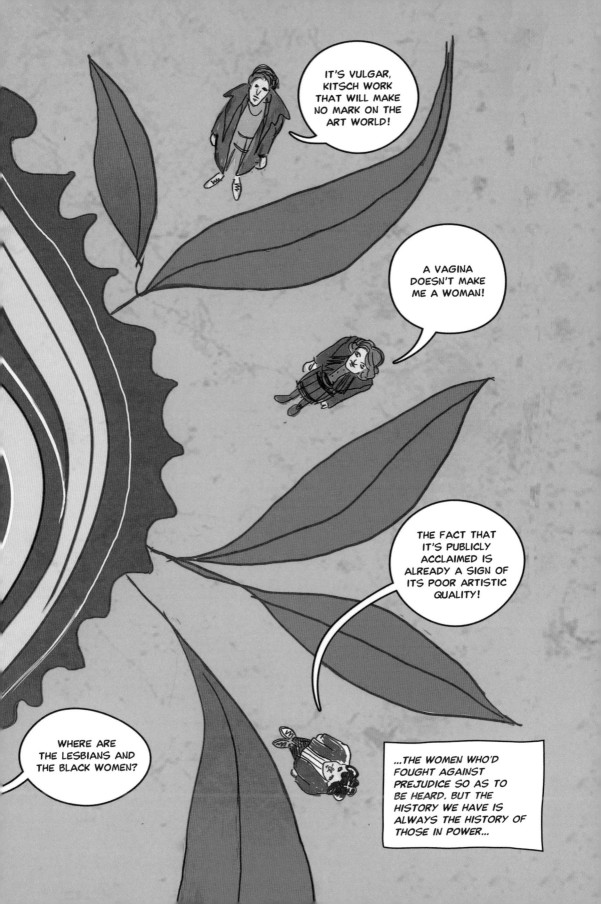

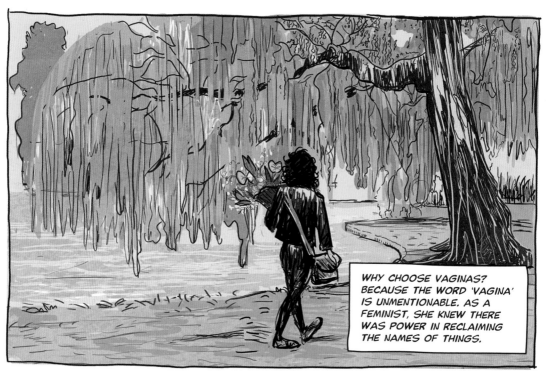

WHY CHOOSE VAGINAS? BECAUSE THE WORD 'VAGINA' IS UNMENTIONABLE. AS A FEMINIST, SHE KNEW THERE WAS POWER IN RECLAIMING THE NAMES OF THINGS.

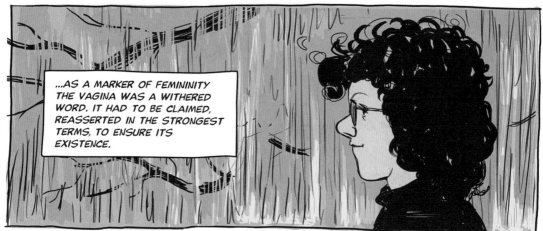

...AS A MARKER OF FEMININITY THE VAGINA WAS A WITHERED WORD. IT HAD TO BE CLAIMED, REASSERTED IN THE STRONGEST TERMS, TO ENSURE ITS EXISTENCE.

WOMEN AREN'T IDEALIZED IMAGES.
HOW MANY FEMALE CERAMICISTS,
CARPENTERS, WRITERS, ARTISTS
AND DESIGNERS HAD SHE WORKED
WITH IN THE LAST FEW YEARS?

EACH WITH THEIR OWN RICH
REPOSITORY OF EMOTION THAT
REVEALED ITSELF: THEY DIDN'T
HAVE TO PROVE THEMSELVES TO
ANYONE ANYMORE...

...AND THEN SHE THOUGHT
OF MIMI...

SANTA CLARITA, CALIFORNIA, 1971

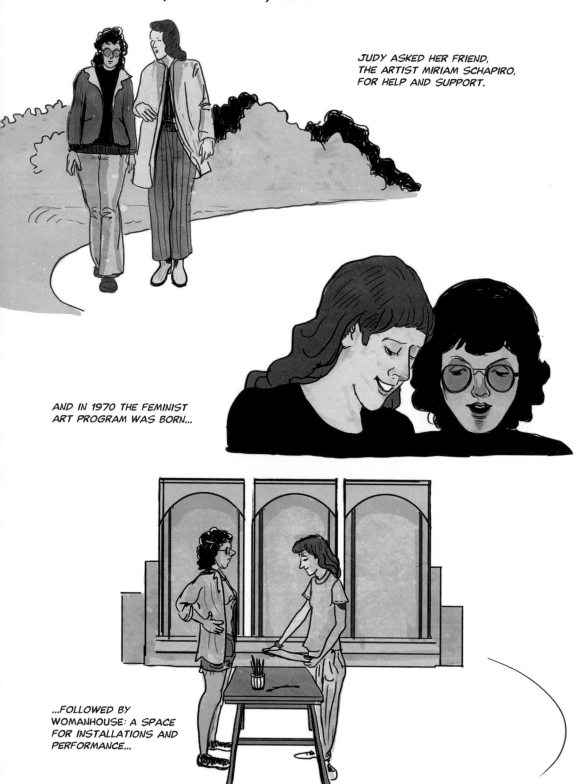

JUDY ASKED HER FRIEND, THE ARTIST MIRIAM SCHAPIRO, FOR HELP AND SUPPORT.

AND IN 1970 THE FEMINIST ART PROGRAM WAS BORN...

...FOLLOWED BY WOMANHOUSE: A SPACE FOR INSTALLATIONS AND PERFORMANCE...

...A HOUSE ENTIRELY
REDESIGNED FROM
A FEMINIST PERSPECTIVE.

MIMI WAS
LIKE JUDY.
SHE BELIEVED
THAT REAL
CHANGE
COMES FROM
WOMEN BEING
CONSCIOUS OF
WHO THEY ARE...

...AND IN SOME WAYS THEY
SUCCEEDED, THEY DEFINED
AN ERA...

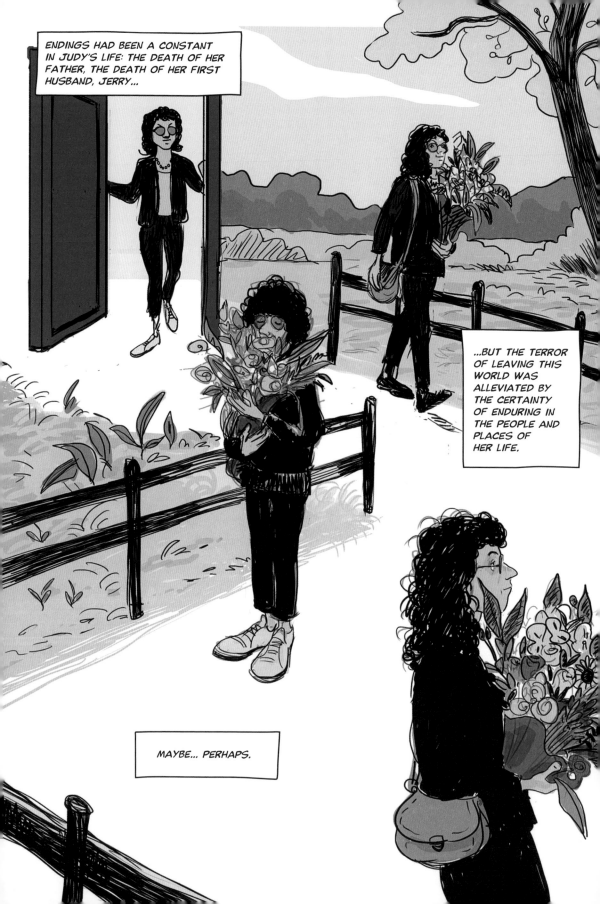

ENDINGS HAD BEEN A CONSTANT IN JUDY'S LIFE: THE DEATH OF HER FATHER, THE DEATH OF HER FIRST HUSBAND, JERRY...

...BUT THE TERROR OF LEAVING THIS WORLD WAS ALLEVIATED BY THE CERTAINTY OF ENDURING IN THE PEOPLE AND PLACES OF HER LIFE.

MAYBE... PERHAPS.

HER PIECE RED FLAG WAS BORN FROM A MEMORY...

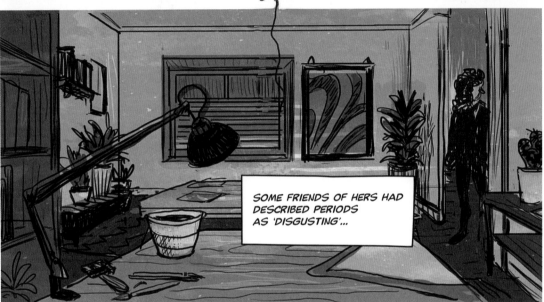

SOME FRIENDS OF HERS HAD DESCRIBED PERIODS AS 'DISGUSTING'...

SO JUDY TOOK A PHOTO OF A BLOODY TAMPON COMING OUT OF A VAGINA. NOT TALKING ABOUT SOMETHING THAT CONCERNS US MEANS DENYING OUR OWN EXISTENCE, BEING ASHAMED OF A PART OF OURSELVES...

...BUT IT NEEDS TO BE SHOWN IN ALL ITS TRUTH: A HAND PULLING OUT A BLOOD-STAINED TAMPON IS PART OF A WOMAN'S LIFE, EVERYONE HAS TO ACCEPT THAT.

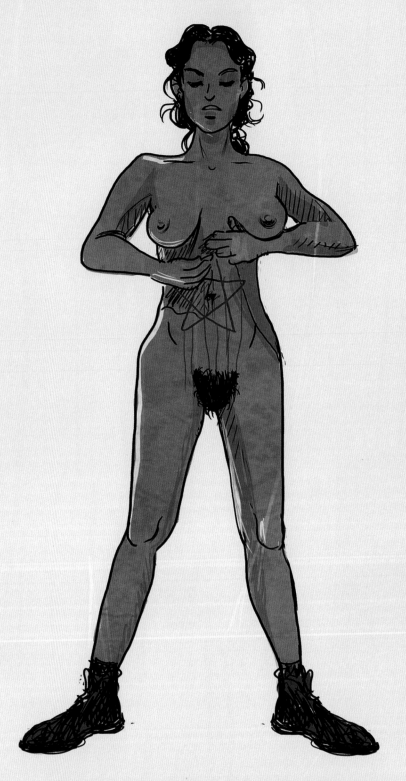

BLOOD FEATURED AGAIN IN MARINA ABRAMOVIĆ'S LIPS OF THOMAS.

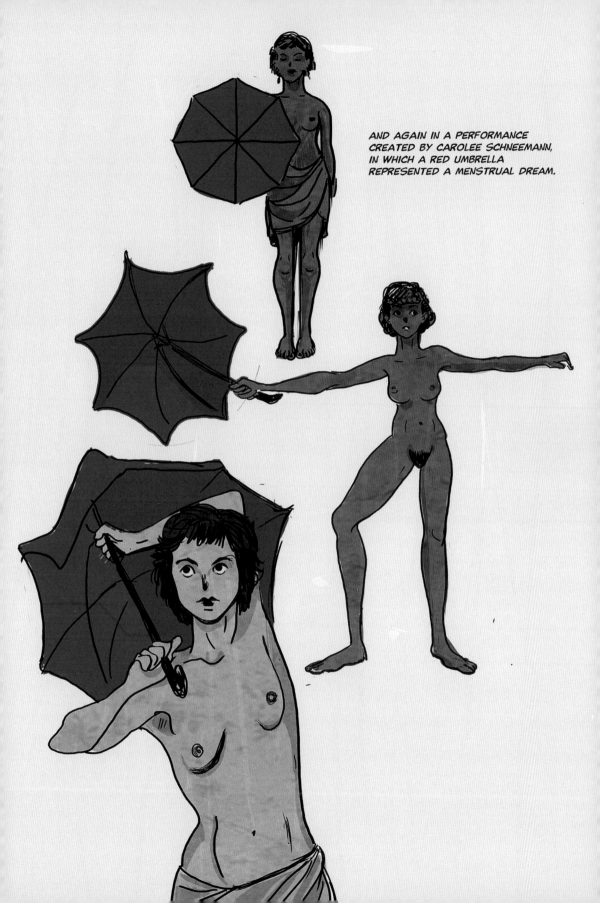

AND AGAIN IN A PERFORMANCE
CREATED BY CAROLEE SCHNEEMANN,
IN WHICH A RED UMBRELLA
REPRESENTED A MENSTRUAL DREAM.

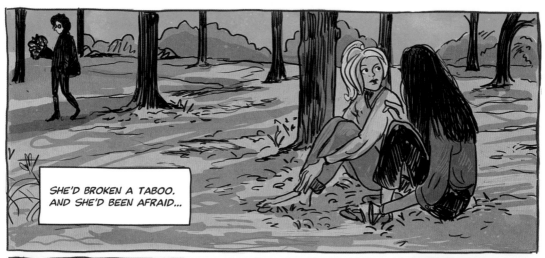

SHE'D BROKEN A TABOO.
AND SHE'D BEEN AFRAID...

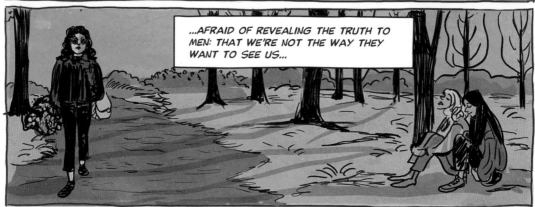

...AFRAID OF REVEALING THE TRUTH TO
MEN: THAT WE'RE NOT THE WAY THEY
WANT TO SEE US...

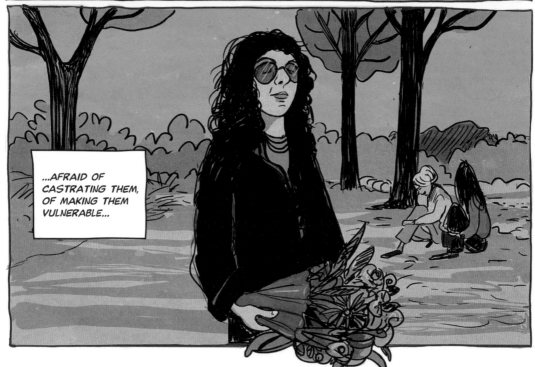

...AFRAID OF
CASTRATING THEM,
OF MAKING THEM
VULNERABLE...

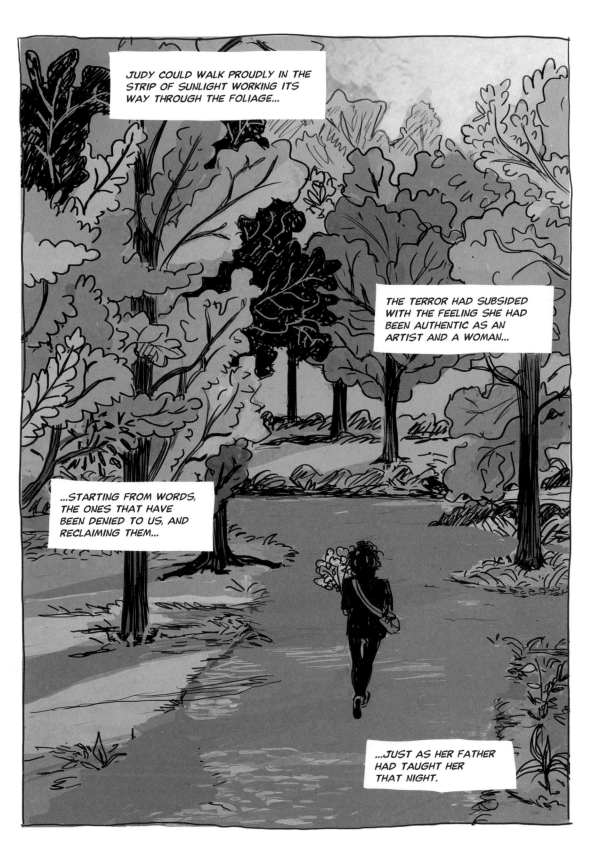

JUDY COULD WALK PROUDLY IN THE STRIP OF SUNLIGHT WORKING ITS WAY THROUGH THE FOLIAGE...

THE TERROR HAD SUBSIDED WITH THE FEELING SHE HAD BEEN AUTHENTIC AS AN ARTIST AND A WOMAN...

...STARTING FROM WORDS, THE ONES THAT HAVE BEEN DENIED TO US, AND RECLAIMING THEM...

...JUST AS HER FATHER HAD TAUGHT HER THAT NIGHT.

CHICAGO, 1952

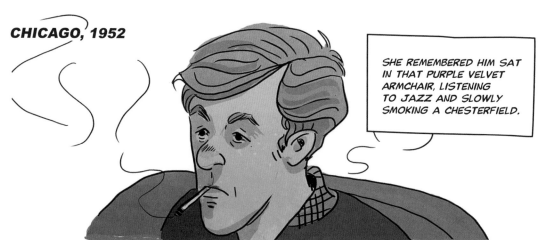

SHE REMEMBERED HIM SAT IN THAT PURPLE VELVET ARMCHAIR, LISTENING TO JAZZ AND SLOWLY SMOKING A CHESTERFIELD.

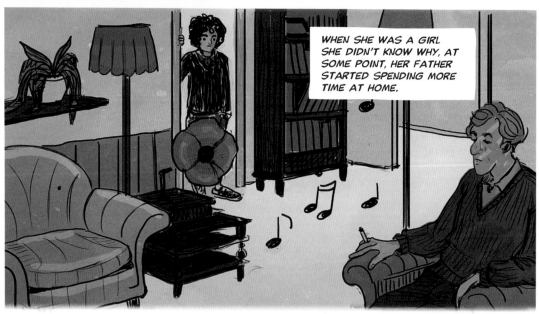

WHEN SHE WAS A GIRL SHE DIDN'T KNOW WHY, AT SOME POINT, HER FATHER STARTED SPENDING MORE TIME AT HOME.

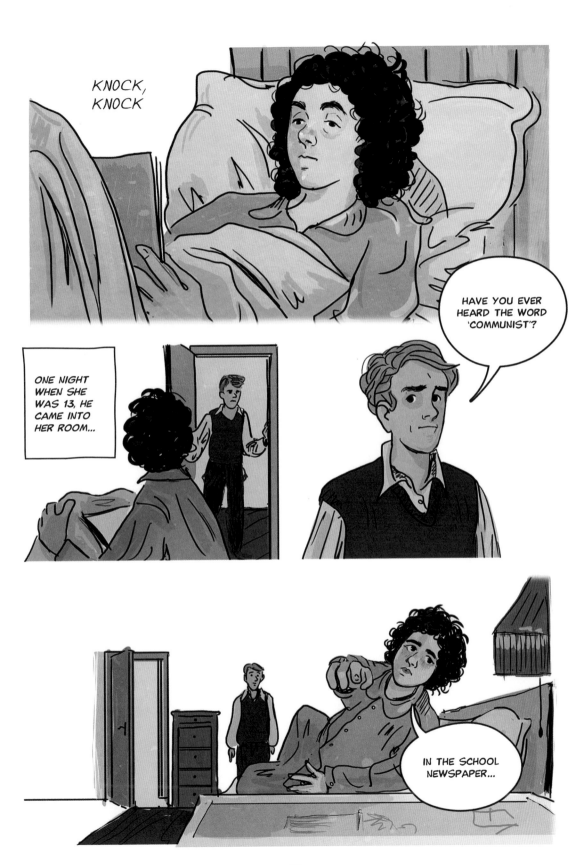

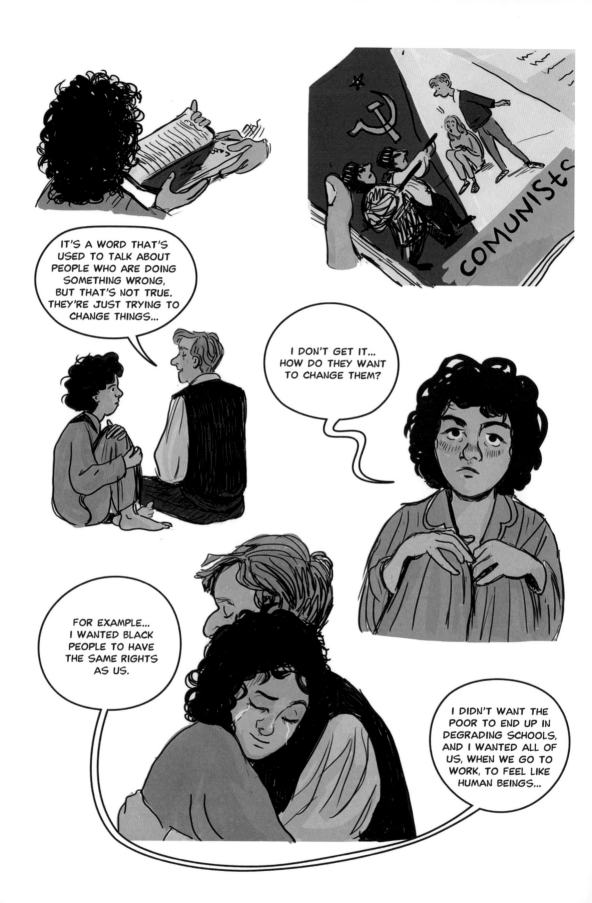

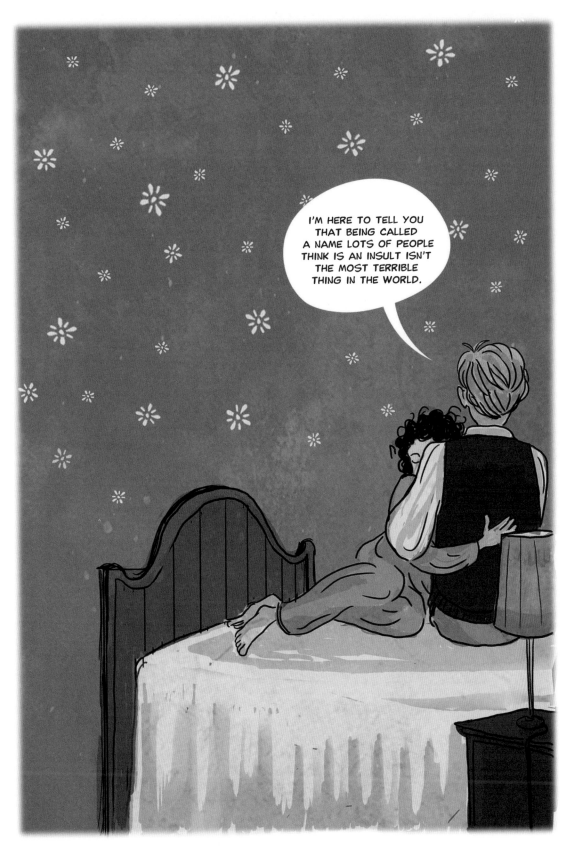

FAITH RINGGOLD

A Voice for African-American Women

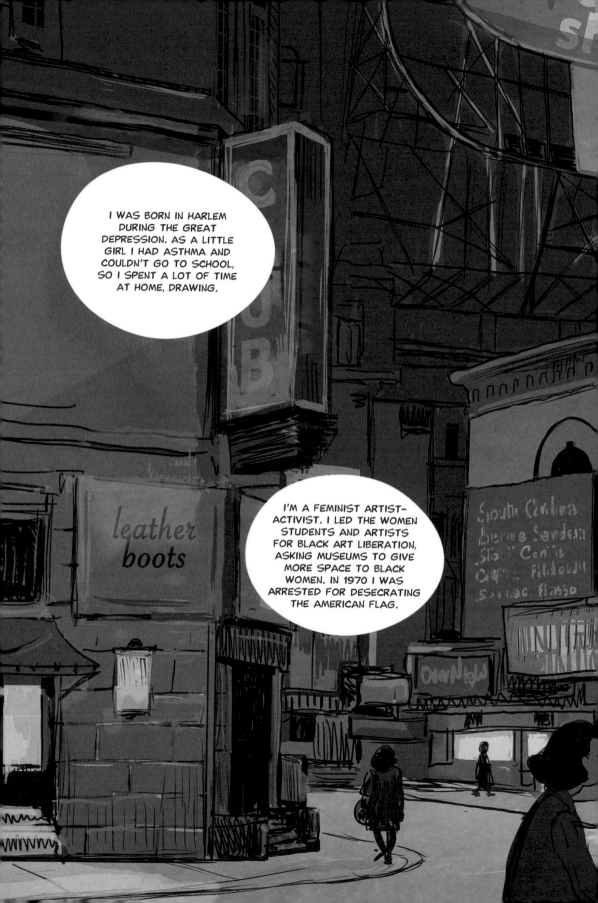

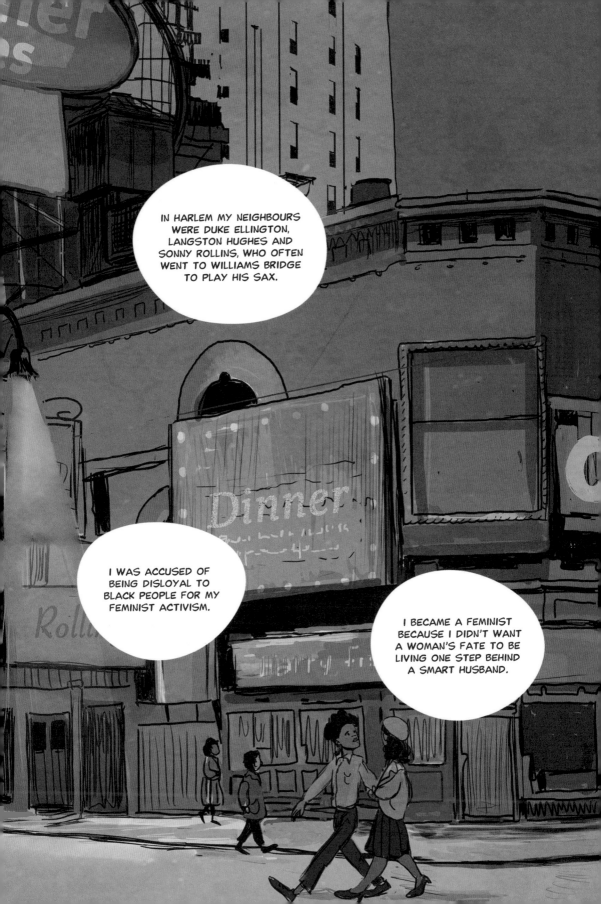

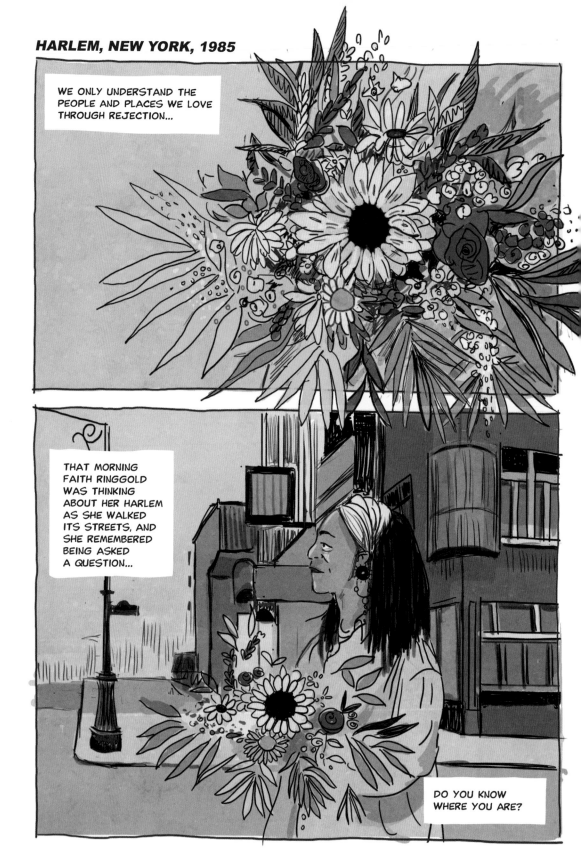

WE ONLY UNDERSTAND THE PEOPLE AND PLACES WE LOVE THROUGH REJECTION...

THAT MORNING FAITH RINGGOLD WAS THINKING ABOUT HER HARLEM AS SHE WALKED ITS STREETS, AND SHE REMEMBERED BEING ASKED A QUESTION...

DO YOU KNOW WHERE YOU ARE?

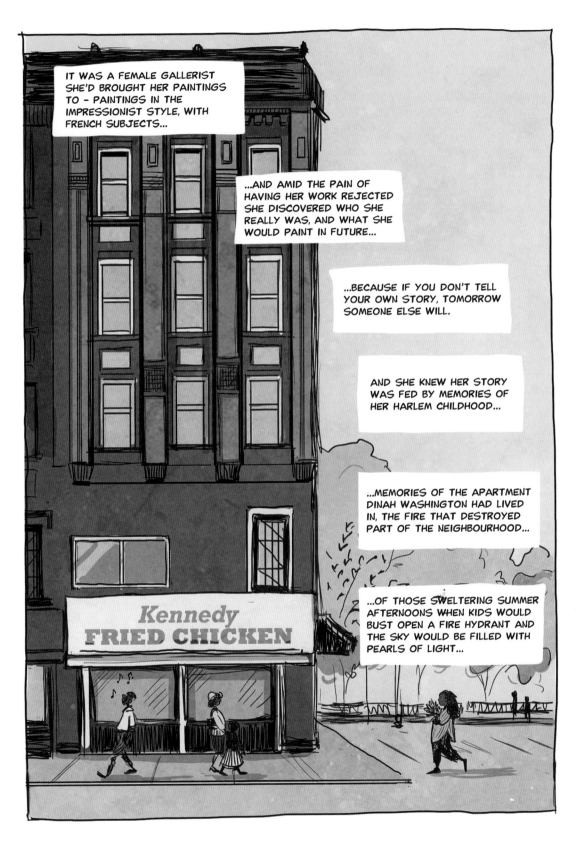

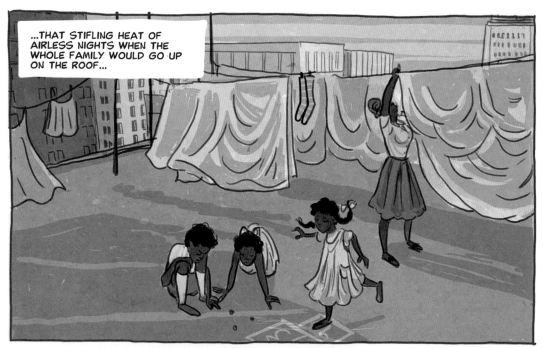

...THAT STIFLING HEAT OF AIRLESS NIGHTS WHEN THE WHOLE FAMILY WOULD GO UP ON THE ROOF...

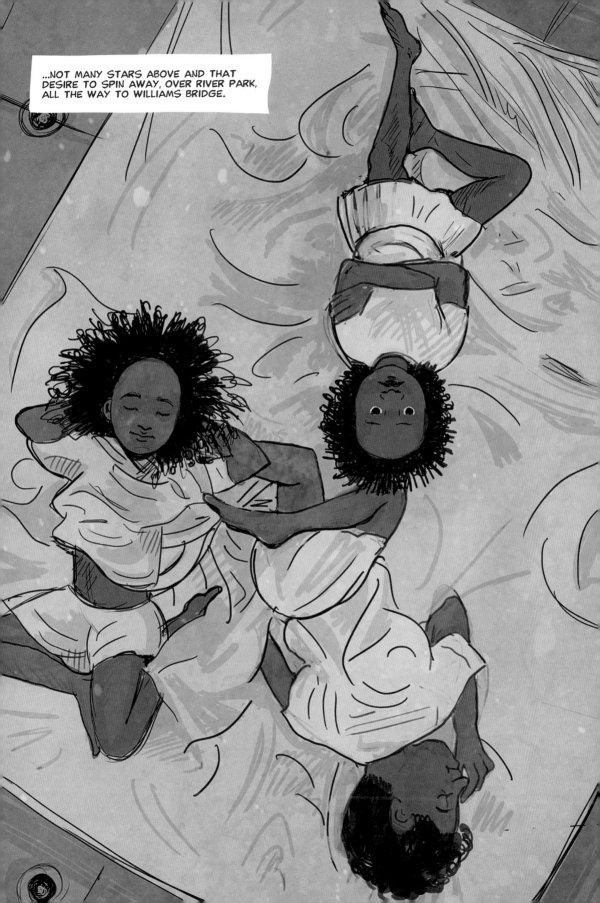

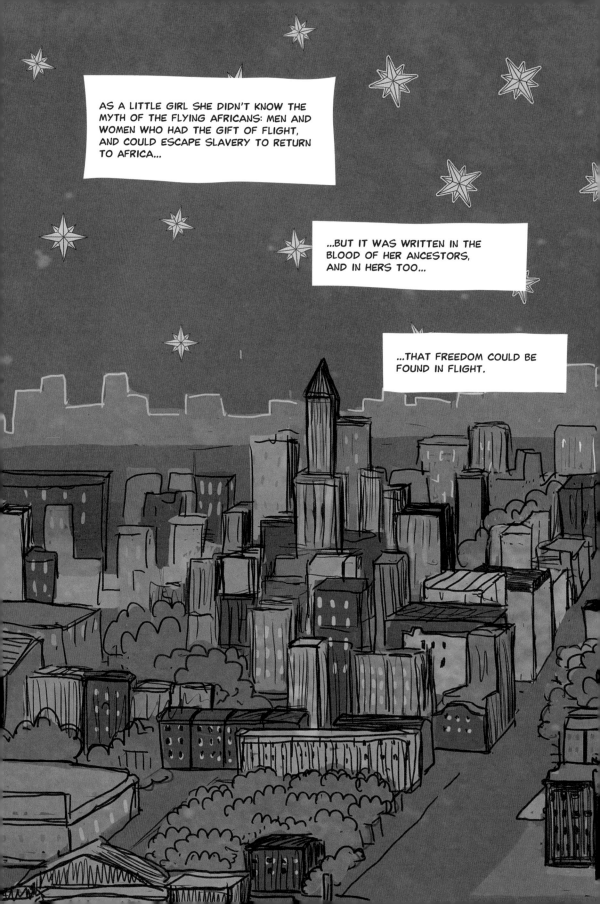

AS A LITTLE GIRL SHE DIDN'T KNOW THE MYTH OF THE FLYING AFRICANS: MEN AND WOMEN WHO HAD THE GIFT OF FLIGHT, AND COULD ESCAPE SLAVERY TO RETURN TO AFRICA...

...BUT IT WAS WRITTEN IN THE BLOOD OF HER ANCESTORS, AND IN HERS TOO...

...THAT FREEDOM COULD BE FOUND IN FLIGHT.

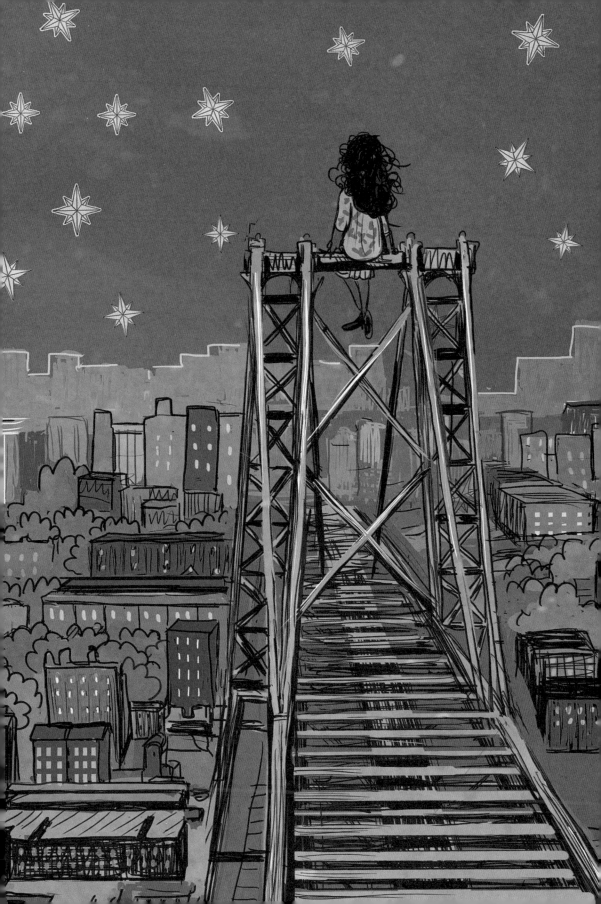

THAT'S WHY FAITH HAD CHOSEN STORY QUILTS AS HER MEDIUM AND ART FORM...

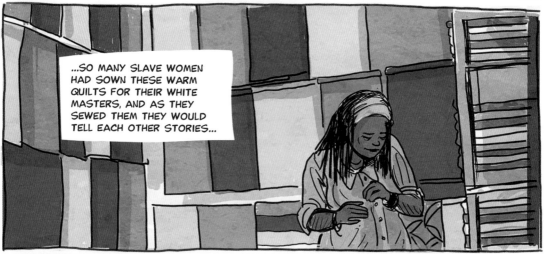

...SO MANY SLAVE WOMEN HAD SOWN THESE WARM QUILTS FOR THEIR WHITE MASTERS, AND AS THEY SEWED THEM THEY WOULD TELL EACH OTHER STORIES...

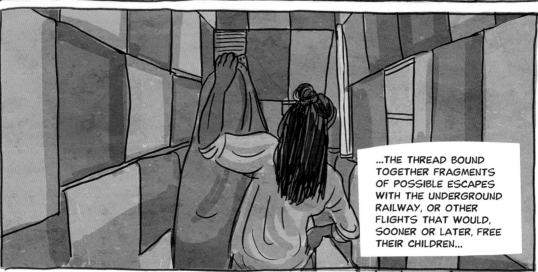

...THE THREAD BOUND TOGETHER FRAGMENTS OF POSSIBLE ESCAPES WITH THE UNDERGROUND RAILWAY, OR OTHER FLIGHTS THAT WOULD, SOONER OR LATER, FREE THEIR CHILDREN...

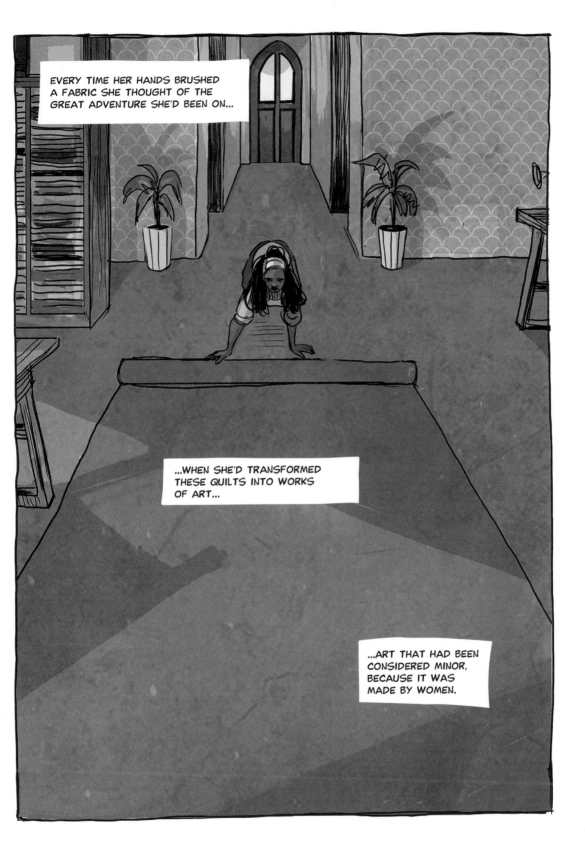

EVERY TIME HER HANDS BRUSHED A FABRIC SHE THOUGHT OF THE GREAT ADVENTURE SHE'D BEEN ON...

...WHEN SHE'D TRANSFORMED THESE QUILTS INTO WORKS OF ART...

...ART THAT HAD BEEN CONSIDERED MINOR, BECAUSE IT WAS MADE BY WOMEN.

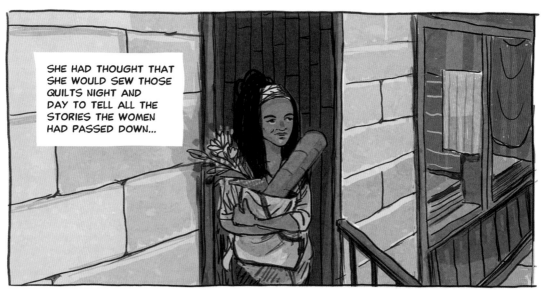

SHE HAD THOUGHT THAT SHE WOULD SEW THOSE QUILTS NIGHT AND DAY TO TELL ALL THE STORIES THE WOMEN HAD PASSED DOWN...

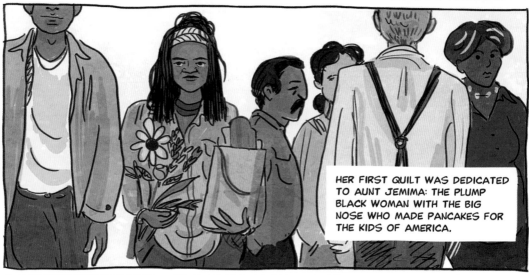

HER FIRST QUILT WAS DEDICATED TO AUNT JEMIMA: THE PLUMP BLACK WOMAN WITH THE BIG NOSE WHO MADE PANCAKES FOR THE KIDS OF AMERICA.

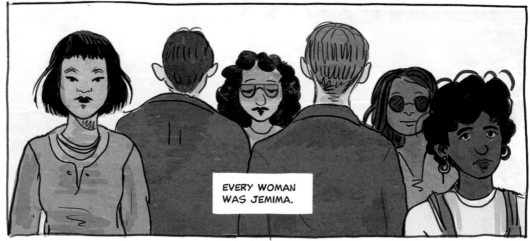

EVERY WOMAN WAS JEMIMA.

IT WAS THE MYTH OF THE SOUTHERN SLAVE, THE SUBMISSIVE MAMMY WHO SERVED WHITE PEOPLE.
IT APPEALED AS MUCH AS UNCLE TOM, THE GOOD BLACK FOLKS, THE ONES WHO NEVER ASK FOR ANYTHING, WHO MAKE NO CLAIMS FOR EQUALITY OR POWER.

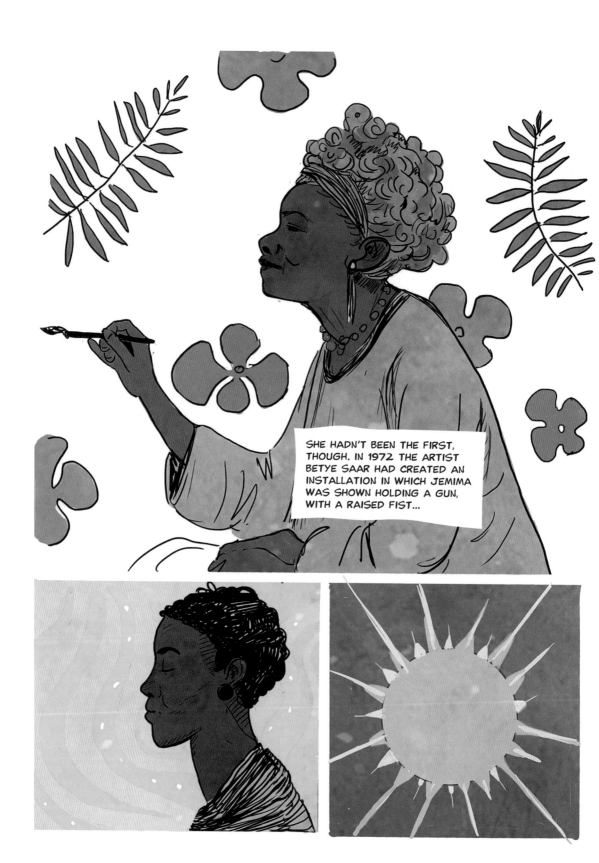

SHE HADN'T BEEN THE FIRST, THOUGH. IN 1972 THE ARTIST BETYE SAAR HAD CREATED AN INSTALLATION IN WHICH JEMIMA WAS SHOWN HOLDING A GUN, WITH A RAISED FIST...

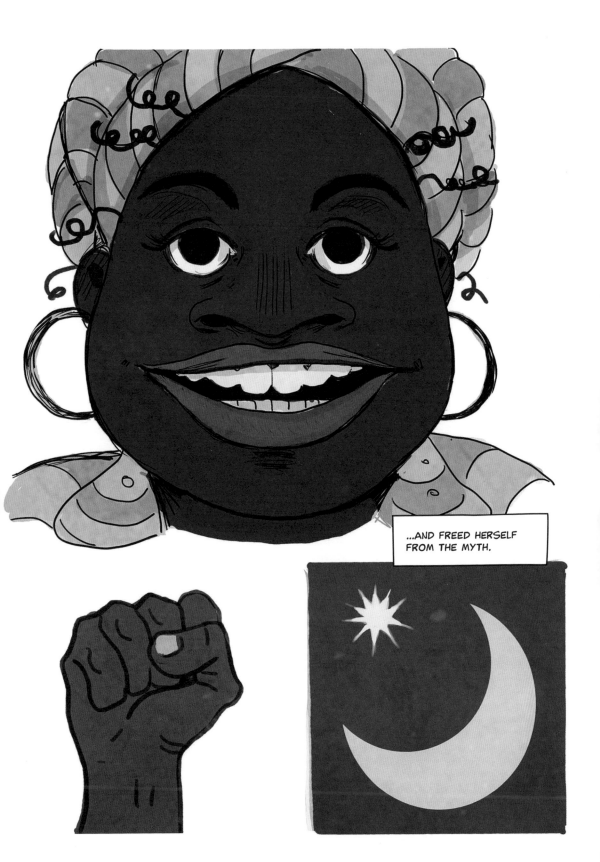

...AND FREED HERSELF FROM THE MYTH.

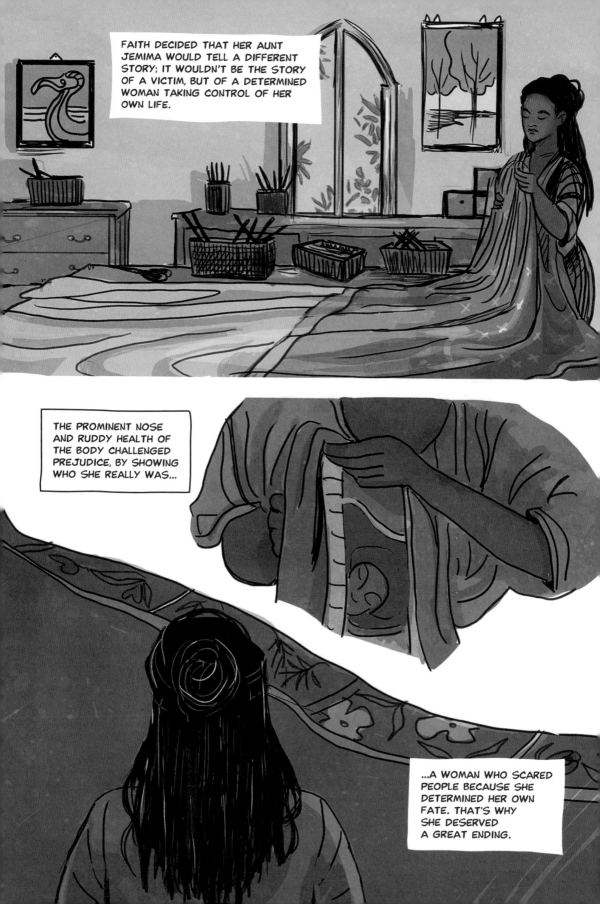

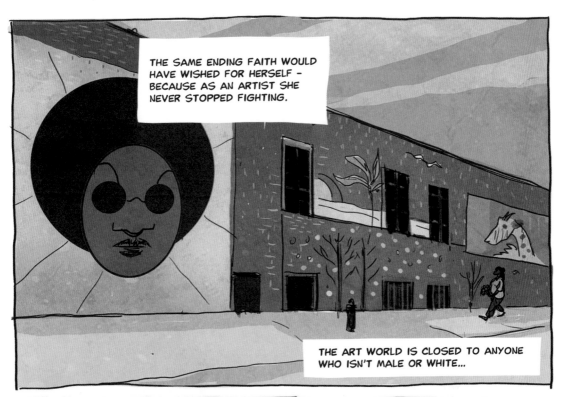

THE SAME ENDING FAITH WOULD HAVE WISHED FOR HERSELF – BECAUSE AS AN ARTIST SHE NEVER STOPPED FIGHTING.

THE ART WORLD IS CLOSED TO ANYONE WHO ISN'T MALE OR WHITE...

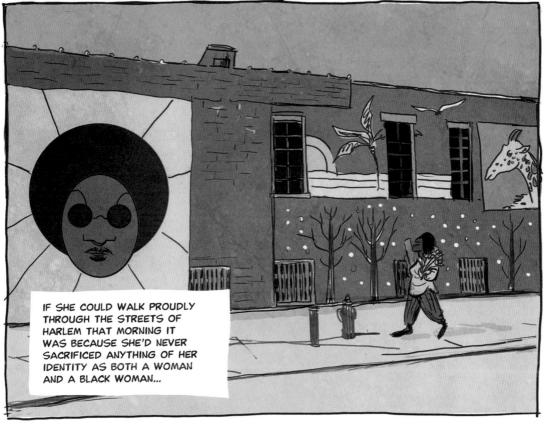

IF SHE COULD WALK PROUDLY THROUGH THE STREETS OF HARLEM THAT MORNING IT WAS BECAUSE SHE'D NEVER SACRIFICED ANYTHING OF HER IDENTITY AS BOTH A WOMAN AND A BLACK WOMAN...

...FROM THE VERY FIRST PROTEST IN NEW YORK CITY BACK IN 1960, WHICH HAD CALLED ON CURATORS TO INCLUDE MORE BLACK ARTISTS IN CONTEMPORARY ART EXHIBITIONS.

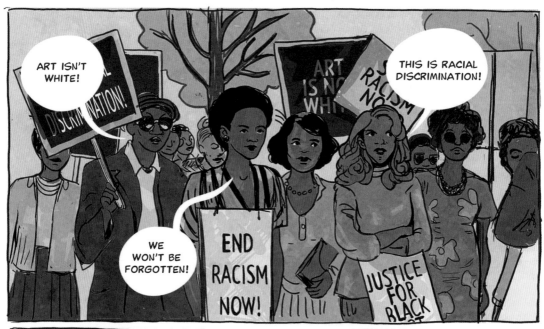

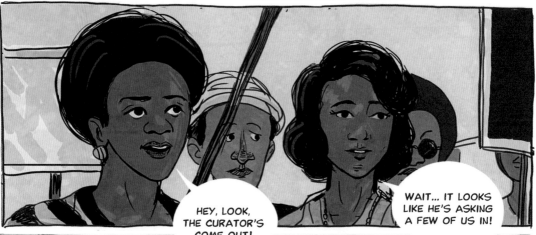

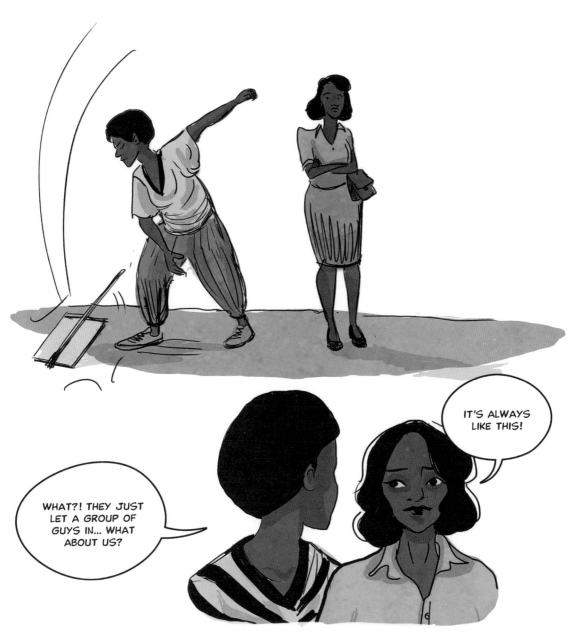

THAT DAY FAITH REALIZED SHE WAS A FEMINIST, AND THAT WAS THE MOMENT HER ACTIVISM BEGAN.

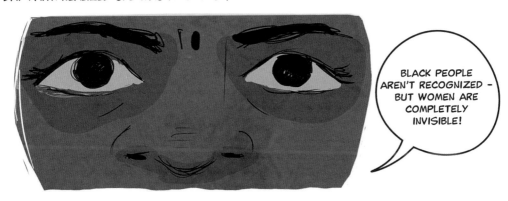

IN 1968 IT WAS HER DAUGHTER MICHELE, A FEMINIST ACTIVIST, WHO HELPED HER REALIZE THEY SHOULD BE ASKING FOR A LOT MORE. THERE WAS A PROTEST PLANNED IN FRONT OF THE WHITNEY MUSEUM...

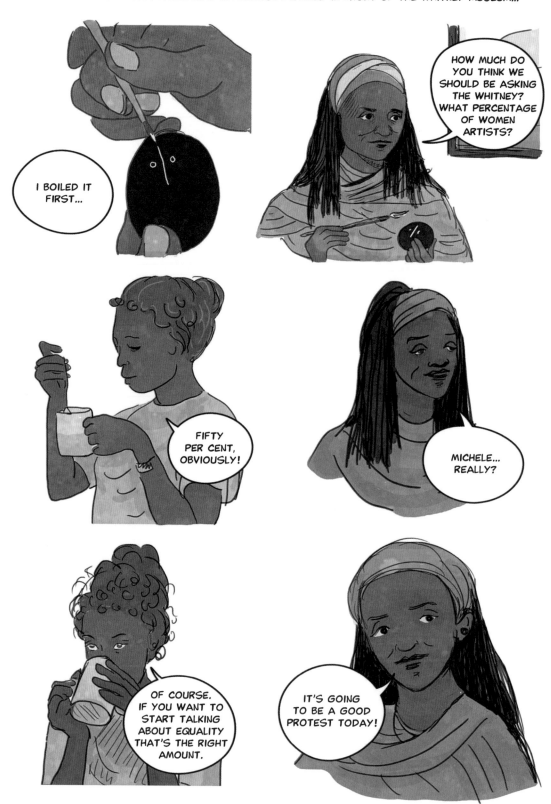

IT HAD BEEN ORGANIZED BY THE AD HOC WOMEN ARTISTS' COMMITTEE. THE ART CRITIC
LUCY LIPPARD AND ARTIST NANCY SPERO WERE THERE TOO.

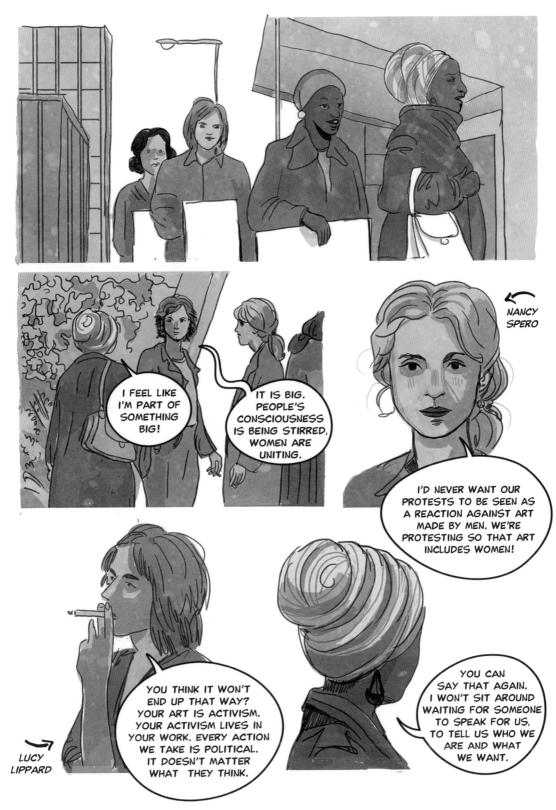

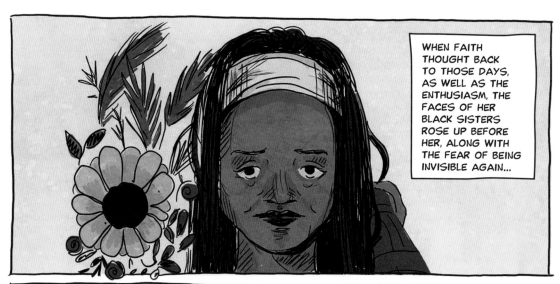

WHEN FAITH THOUGHT BACK TO THOSE DAYS, AS WELL AS THE ENTHUSIASM, THE FACES OF HER BLACK SISTERS ROSE UP BEFORE HER, ALONG WITH THE FEAR OF BEING INVISIBLE AGAIN...

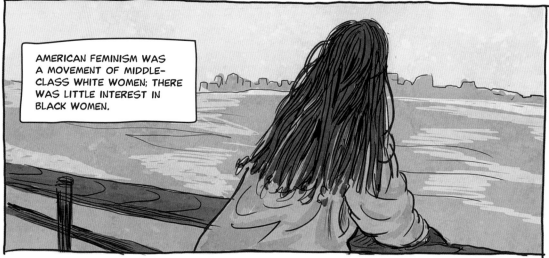

AMERICAN FEMINISM WAS A MOVEMENT OF MIDDLE-CLASS WHITE WOMEN; THERE WAS LITTLE INTEREST IN BLACK WOMEN.

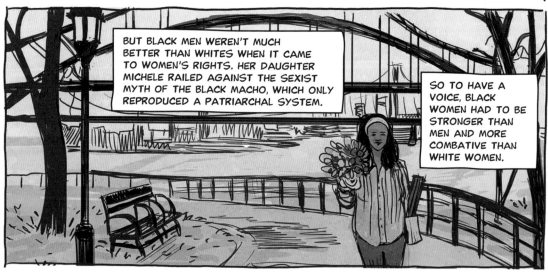

BUT BLACK MEN WEREN'T MUCH BETTER THAN WHITES WHEN IT CAME TO WOMEN'S RIGHTS. HER DAUGHTER MICHELE RAILED AGAINST THE SEXIST MYTH OF THE BLACK MACHO, WHICH ONLY REPRODUCED A PATRIARCHAL SYSTEM.

SO TO HAVE A VOICE, BLACK WOMEN HAD TO BE STRONGER THAN MEN AND MORE COMBATIVE THAN WHITE WOMEN.

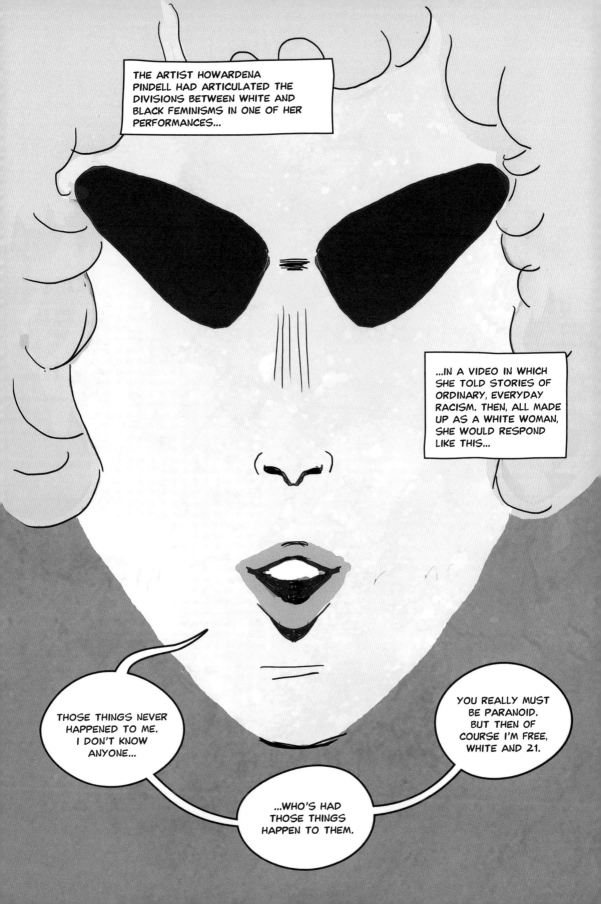

FAITH THOUGHT ABOUT HOW, IN SPITE OF EVERYTHING, AT THAT TIME PEOPLE STILL BELIEVED THEY COULD CHANGE THE WORLD. IT WASN'T LIKE THAT ANYMORE.

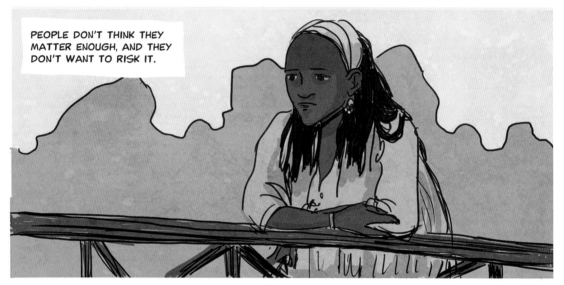

PEOPLE DON'T THINK THEY MATTER ENOUGH, AND THEY DON'T WANT TO RISK IT.

BUT RISK IS THE ENGINE OF CREATIVITY, FEAR ITS GREAT ENEMY...

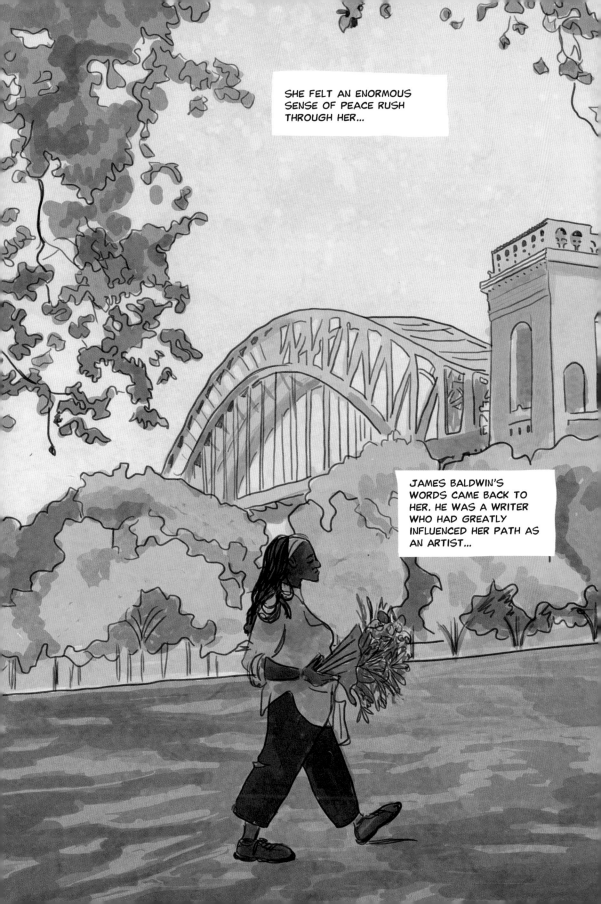

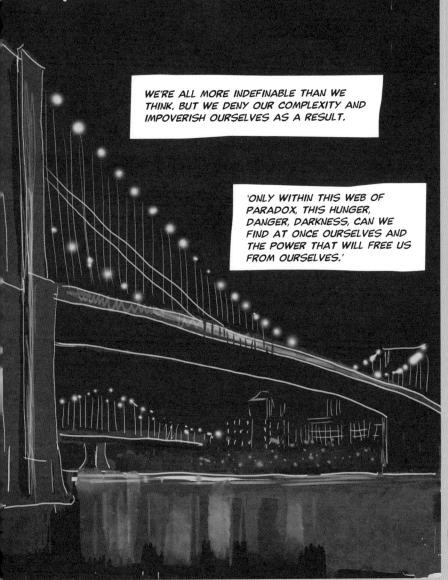

WE'RE ALL MORE INDEFINABLE THAN WE THINK. BUT WE DENY OUR COMPLEXITY AND IMPOVERISH OURSELVES AS A RESULT.

'ONLY WITHIN THIS WEB OF PARADOX, THIS HUNGER, DANGER, DARKNESS, CAN WE FIND AT ONCE OURSELVES AND THE POWER THAT WILL FREE US FROM OURSELVES.'

ANA MENDIETA

Pushing the Boundaries of Identity

I WAS BORN IN CUBA. MY FATHER WAS A LAWYER AND
MY MOTHER WAS A CHEMIST.

MY PARENTS DECIDED TO ENTRUST ME AND MY SISTER
RAQUELIN TO OPERATION PETER PAN, TO ENABLE US TO
EMIGRATE TO THE UNITED STATES. I WAS 12 YEARS OLD.

I LIVED IN REFUGEE CAMPS AND FOSTER HOMES
IN IOWA, AND ONLY SAW MY MOTHER AND BROTHER
FIVE YEARS LATER, WHILE MY FATHER SERVED
A POLITICAL SENTENCE IN HAVANA.

I FELL IN LOVE WITH ART WHEN I WAS 13, EVEN THOUGH
MY TEACHERS THOUGHT I HAD NO TALENT.

KIDS MY AGE MADE FUN OF ME FOR BEING CUBAN.

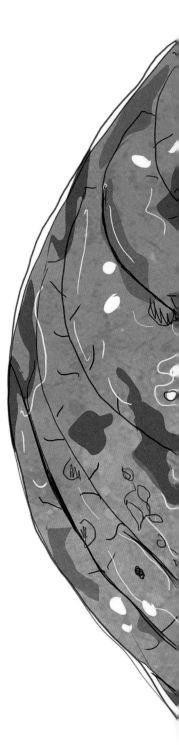

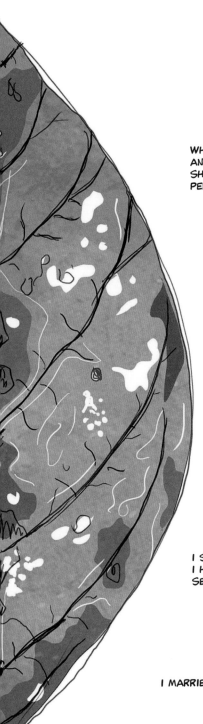

WHEN I WAS AT COLLEGE A FEMALE STUDENT WAS RAPED AND KILLED ON CAMPUS. HER NAME WAS SARA OTTEN AND SHE WAS MY AGE. THE EVENT INSPIRED MY FIRST PERFORMANCE PIECE.

MY BODY BELONGS TO THE EARTH AND I TRY TO RETURN TO IT IN MY WORKS: THEY'RE AN EXTENSION OF THE FEMININE ENERGY THAT FLOWS THROUGH EVERYTHING.

I WAS PART OF THE FIRST GALLERY FOR WOMEN FOUNDED IN NEW YORK, A.I.R.

I SOUGHT A CONNECTION BETWEEN MY BODY AND THE LANDSCAPES I HAD BEEN THROUGH, IMPRINTING MY SILHOUETTE ONTO THEM, SEARCHING FOR A WAY BACK TO MOTHER EARTH.

I MARRIED A SCULPTOR.

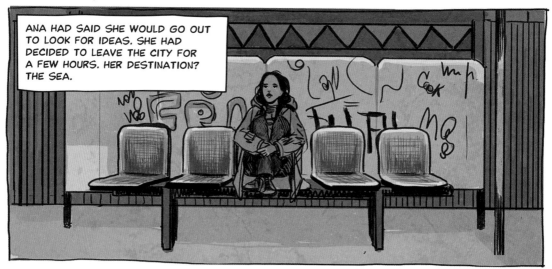

ANA HAD SAID SHE WOULD GO OUT TO LOOK FOR IDEAS. SHE HAD DECIDED TO LEAVE THE CITY FOR A FEW HOURS. HER DESTINATION? THE SEA.

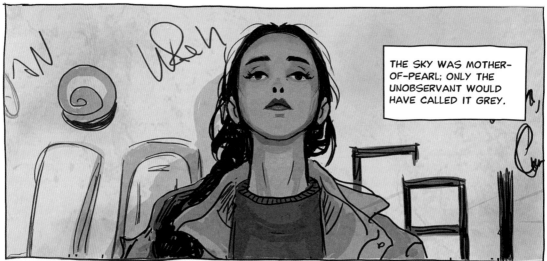

THE SKY WAS MOTHER-OF-PEARL; ONLY THE UNOBSERVANT WOULD HAVE CALLED IT GREY.

IT REMINDED HER OF THE MORNINGS WHEN SHE WOULD GO TO PLAYA DEL ESTE WITH HER SISTER...

...THE SUN WOULD JOIN THEM SOON ENOUGH...

...AND THE SAND WOULD TURN SCORCHINGLY HOT...

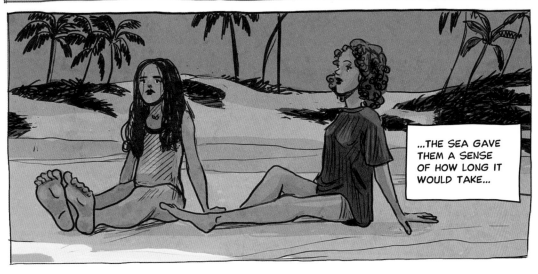

...THE SEA GAVE THEM A SENSE OF HOW LONG IT WOULD TAKE...

SOON CAME THE ESCAPE FROM CUBA, AND IOWA...

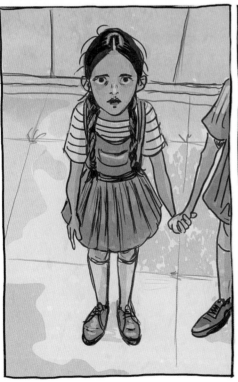

BUILDINGS LIKE BEEHIVES, FOSTER HOMES AND DAMP ORPHANAGES; SKIES BLOATED WITH BITTER RAIN...

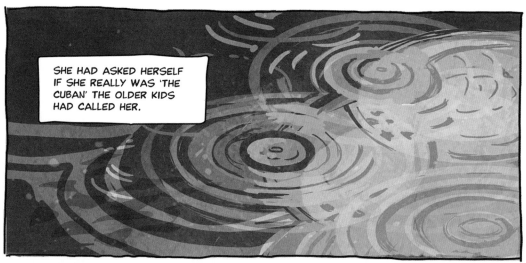

SHE HAD ASKED HERSELF IF SHE REALLY WAS 'THE CUBAN' THE OLDER KIDS HAD CALLED HER.

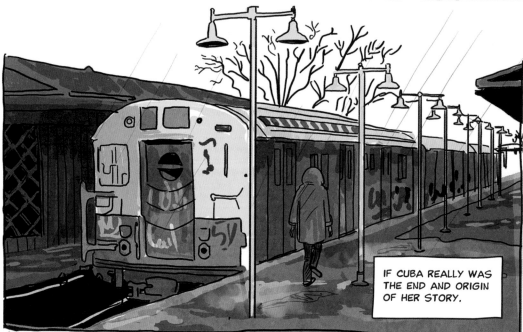

IF CUBA REALLY WAS THE END AND ORIGIN OF HER STORY.

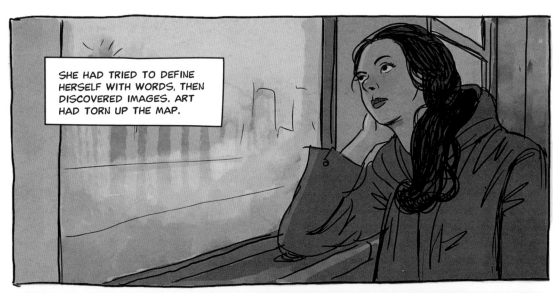

SHE HAD TRIED TO DEFINE HERSELF WITH WORDS, THEN DISCOVERED IMAGES. ART HAD TORN UP THE MAP.

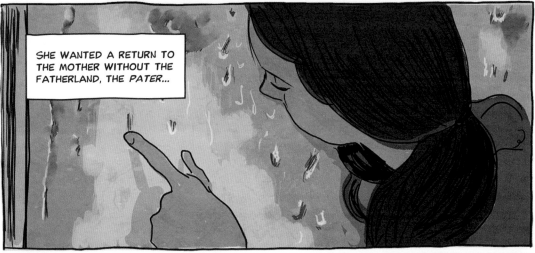

SHE WANTED A RETURN TO THE MOTHER WITHOUT THE FATHERLAND, THE *PATER...*

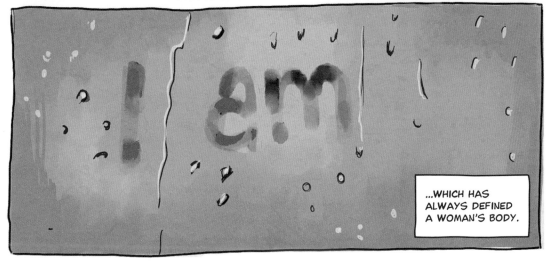

...WHICH HAS ALWAYS DEFINED A WOMAN'S BODY.

SHE BELIEVED IN BODY ART: WITH IT SHE PUT FORWARD A DIFFERENT NARRATIVE OF THE FEMALE BODY...

...BECAUSE THE FLESH CAN TAKE AS MANY FORMS AS THERE ARE POSSIBILITIES.

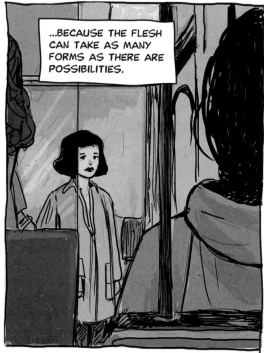

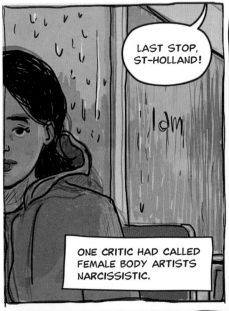

LAST STOP, ST-HOLLAND!

ONE CRITIC HAD CALLED FEMALE BODY ARTISTS NARCISSISTIC.

WASN'T IT ALWAYS LIKE THAT FOR WOMEN?

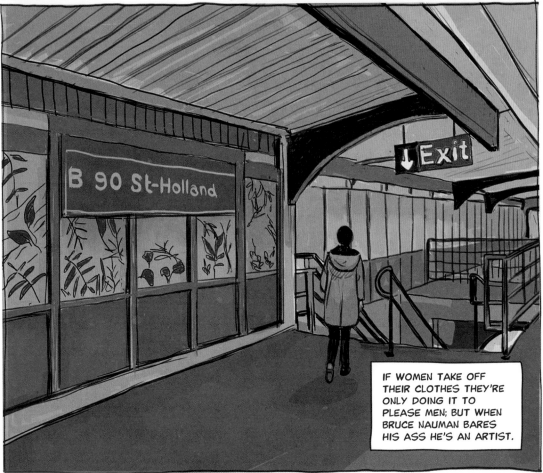

IF WOMEN TAKE OFF THEIR CLOTHES THEY'RE ONLY DOING IT TO PLEASE MEN; BUT WHEN BRUCE NAUMAN BARES HIS ASS HE'S AN ARTIST.

81

MAN, WOMAN. EVERY BODY IS A SOCIAL CONSTRUCT...

...BUT WHAT ABOUT IDENTITY?

COFFEE, PLEASE.

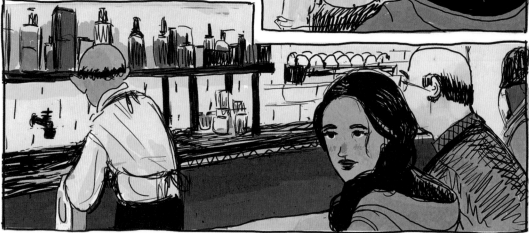

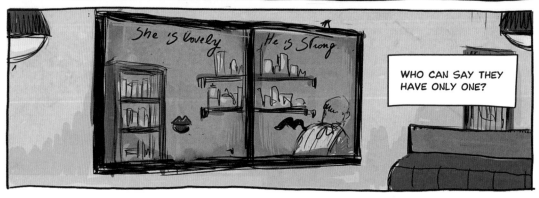

She is lovely He is strong

WHO CAN SAY THEY HAVE ONLY ONE?

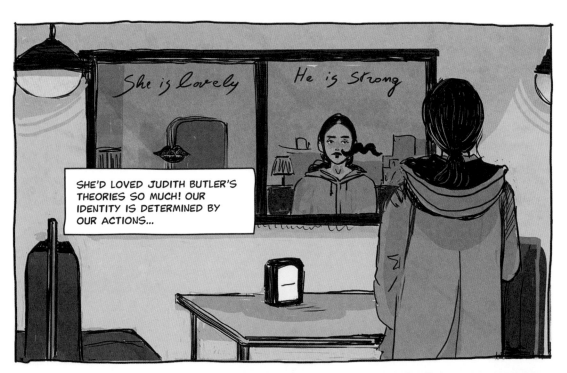

SHE'D LOVED JUDITH BUTLER'S THEORIES SO MUCH! OUR IDENTITY IS DETERMINED BY OUR ACTIONS...

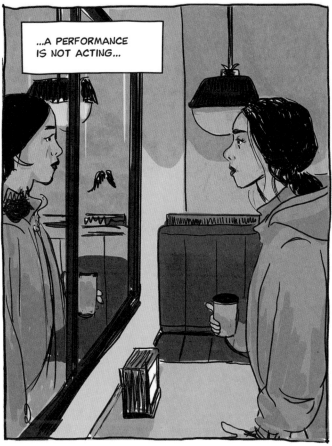

...A PERFORMANCE IS NOT ACTING...

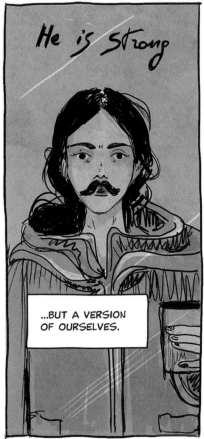

...BUT A VERSION OF OURSELVES.

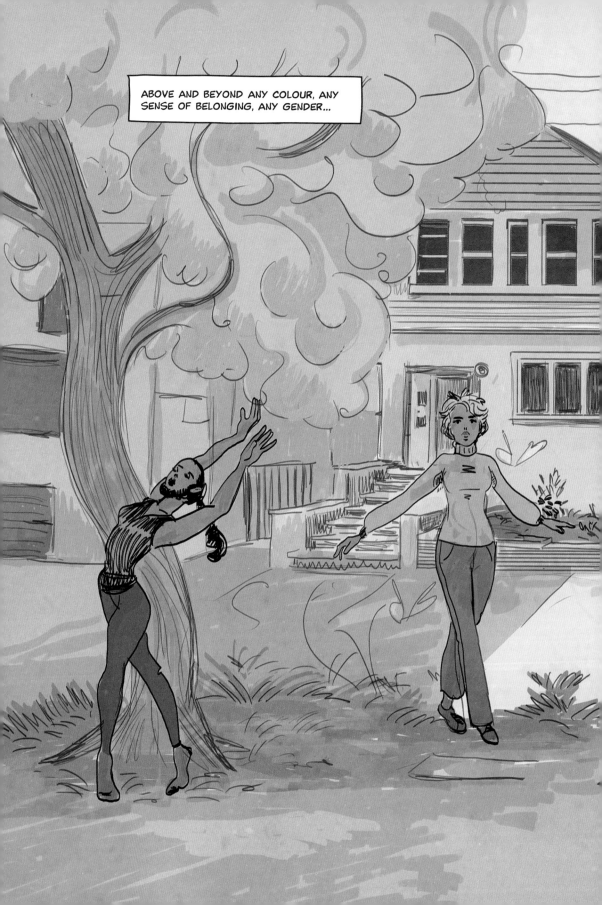

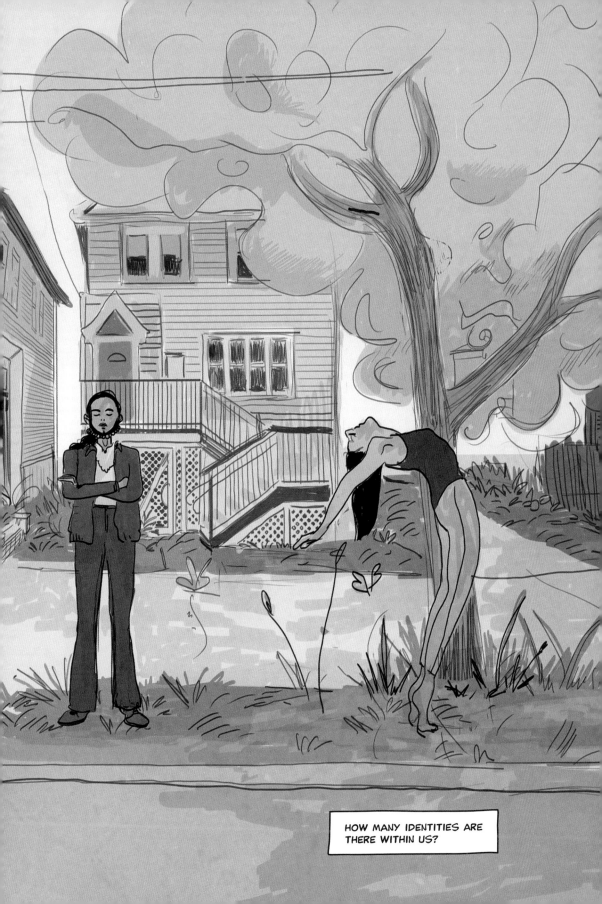

HOW MANY IDENTITIES ARE
THERE WITHIN US?

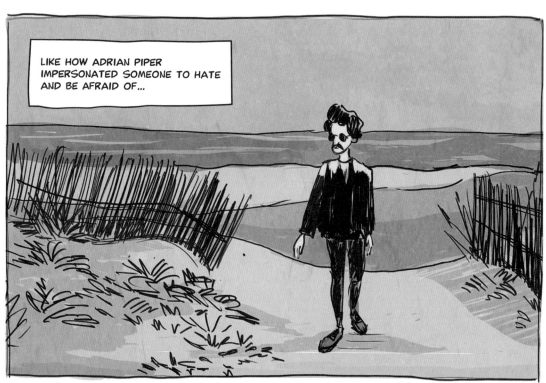

LIKE HOW ADRIAN PIPER IMPERSONATED SOMEONE TO HATE AND BE AFRAID OF...

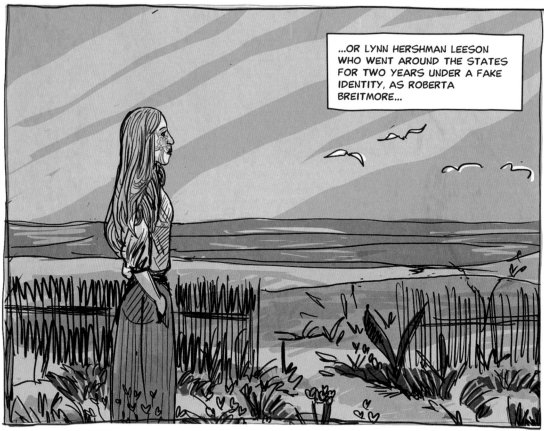

...OR LYNN HERSHMAN LEESON WHO WENT AROUND THE STATES FOR TWO YEARS UNDER A FAKE IDENTITY, AS ROBERTA BREITMORE...

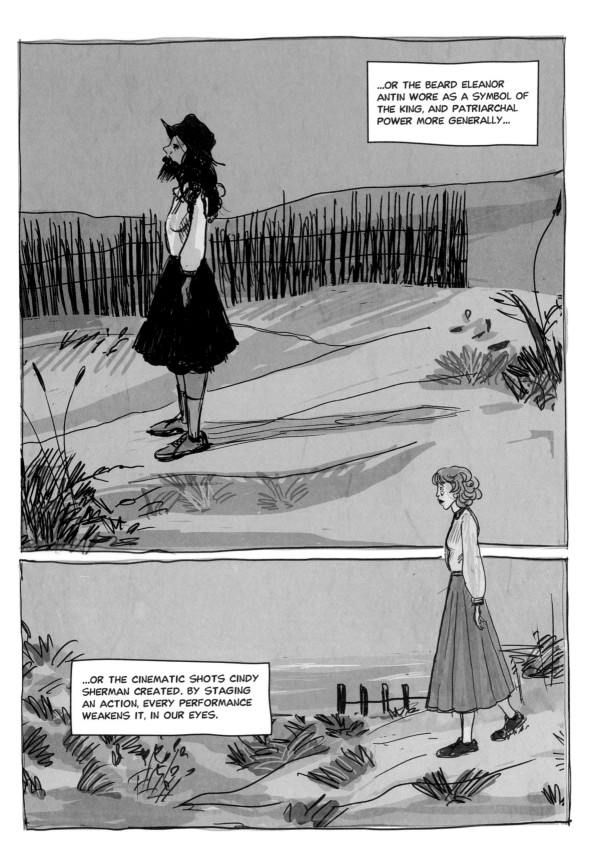

...OR THE BEARD ELEANOR ANTIN WORE AS A SYMBOL OF THE KING, AND PATRIARCHAL POWER MORE GENERALLY...

...OR THE CINEMATIC SHOTS CINDY SHERMAN CREATED. BY STAGING AN ACTION, EVERY PERFORMANCE WEAKENS IT, IN OUR EYES.

SHE DIDN'T MIND THE CITY, BUT SHE ALWAYS FELT BEST IN NATURE.

SHE FELT SHE WAS PART OF A SINGLE UNIVERSAL ENERGY THAT FLOWS AND REVERBERATES THROUGH ALL THINGS...

...THE GRAIN OF SAND CRACKLING UNDER HER FEET, THE PLANT RUSTLING AT THE TOUCH OF HER HAND...

...THE WIND TEARING UP THE DUST AND POLLEN.

THAT WOULD HAVE BEEN THE PERFECT STICK FOR A GAME WITH RAQUELIN...

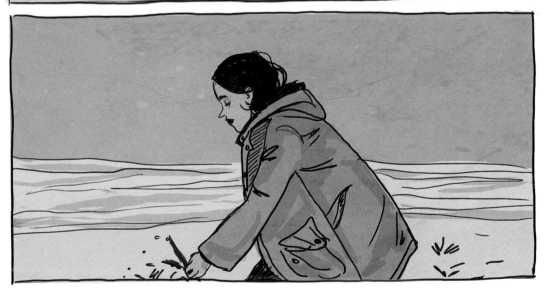

IF I WIN... WHEN WE GET TO THE STATES YOU'LL TAKE ME TO THE PICTURES EVERY NIGHT!

YEAH, RIGHT! YOU'RE ALWAYS CHEATING, TAKING LITTLE BITS OF SAND OFF THE BOTTOM!

JUST THINK! WE'LL BE ABLE TO MEET CARY GRANT AND MARILYN MONROE!

RIGHT, WE'RE ALL THEY'RE WAITING FOR...

PLEASE DON'T FALL LITTLE STICK, LET'S SHOW MY BIG SISTER I'M NO CHEAT...

YOUR TURN!

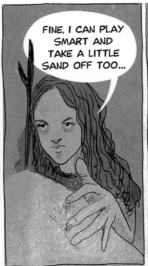

FINE, I CAN PLAY SMART AND TAKE A LITTLE SAND OFF TOO...

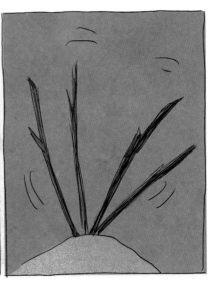

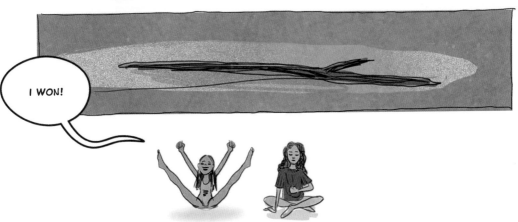

I WON!

ANOTHER EXTRAORDINARY FEAT BY THE INCREDIBLE MISS ANA MENDIETA!

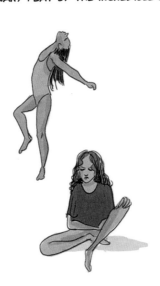

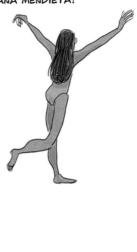

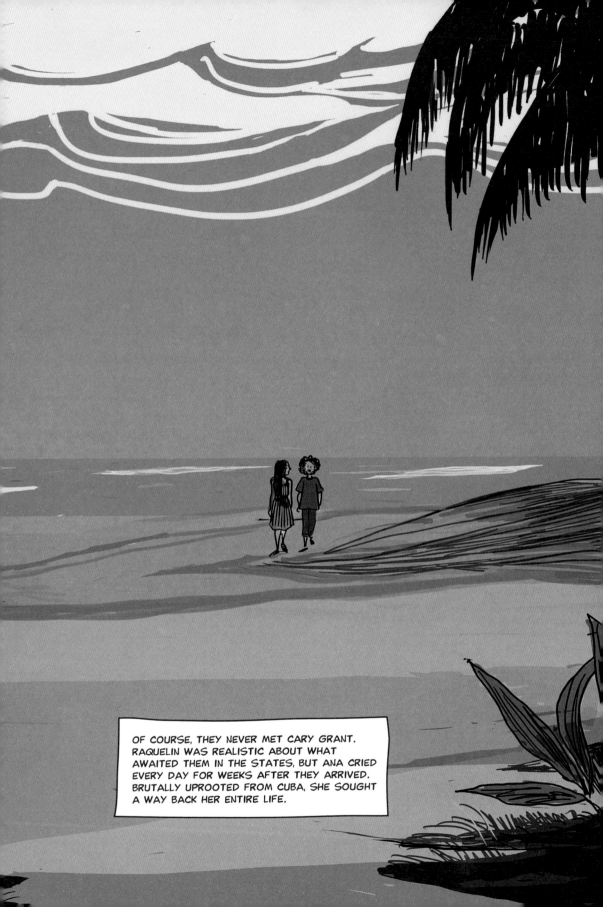

OF COURSE, THEY NEVER MET CARY GRANT.
RAQUELIN WAS REALISTIC ABOUT WHAT
AWAITED THEM IN THE STATES, BUT ANA CRIED
EVERY DAY FOR WEEKS AFTER THEY ARRIVED.
BRUTALLY UPROOTED FROM CUBA, SHE SOUGHT
A WAY BACK HER ENTIRE LIFE.

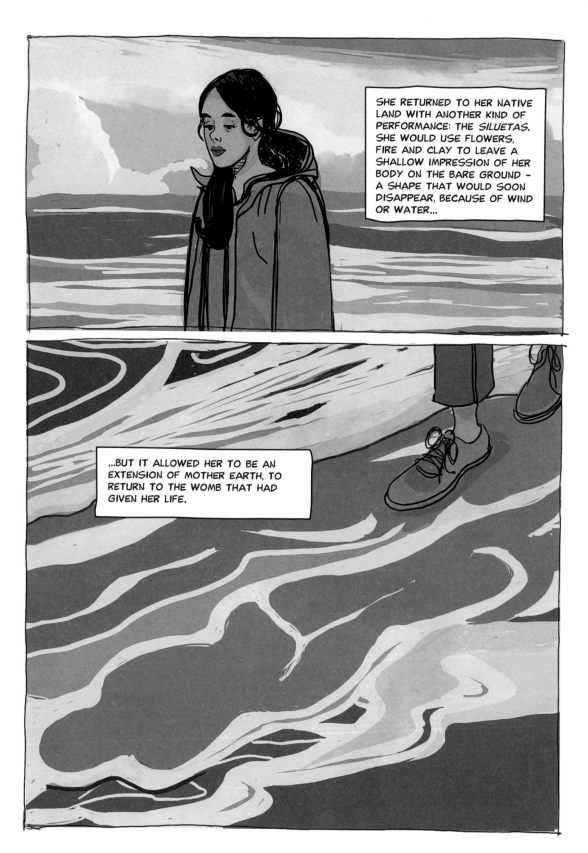

SHE RETURNED TO HER NATIVE LAND WITH ANOTHER KIND OF PERFORMANCE: THE *SILUETAS*. SHE WOULD USE FLOWERS, FIRE AND CLAY TO LEAVE A SHALLOW IMPRESSION OF HER BODY ON THE BARE GROUND – A SHAPE THAT WOULD SOON DISAPPEAR, BECAUSE OF WIND OR WATER...

...BUT IT ALLOWED HER TO BE AN EXTENSION OF MOTHER EARTH, TO RETURN TO THE WOMB THAT HAD GIVEN HER LIFE.

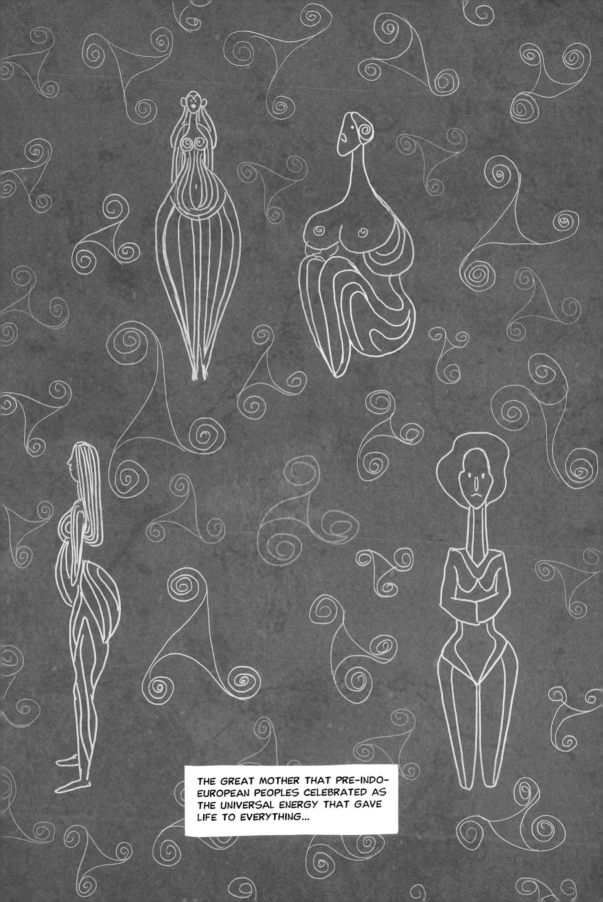

THE GREAT MOTHER THAT PRE-INDO-EUROPEAN PEOPLES CELEBRATED AS THE UNIVERSAL ENERGY THAT GAVE LIFE TO EVERYTHING...

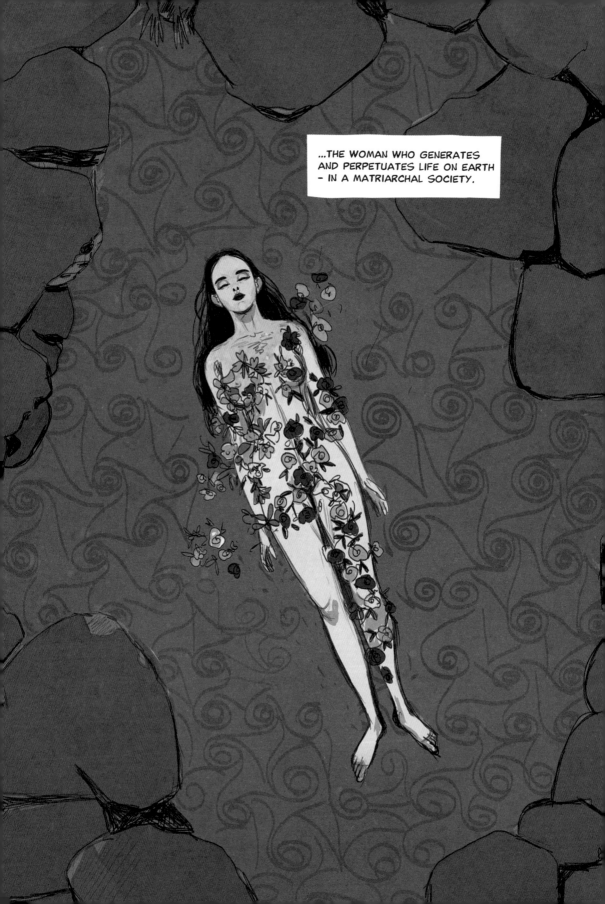

...THE WOMAN WHO GENERATES AND PERPETUATES LIFE ON EARTH – IN A MATRIARCHAL SOCIETY.

MEN ARTISTS DON'T WORK IN NATURE...

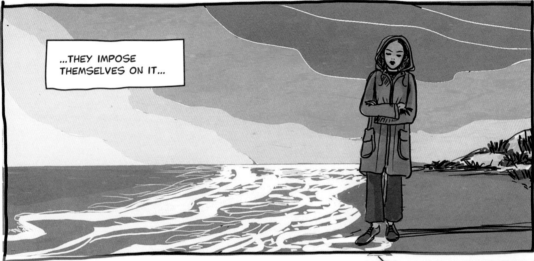

...THEY IMPOSE THEMSELVES ON IT...

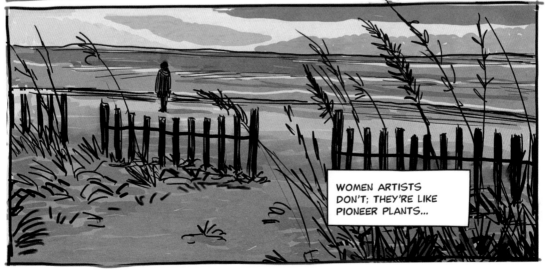

WOMEN ARTISTS DON'T; THEY'RE LIKE PIONEER PLANTS...

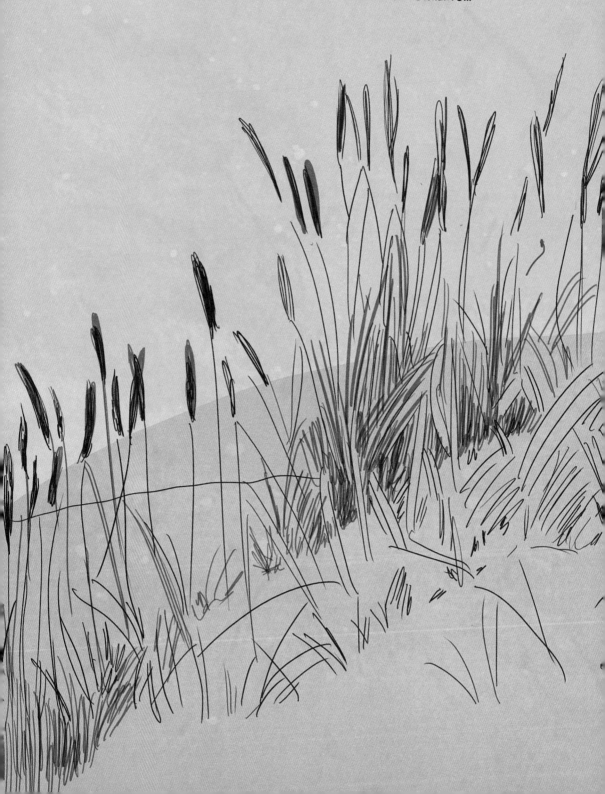

...THEY GIVE LIFE TO SOILS THAT ARE LOW ON NUTRIENTS...

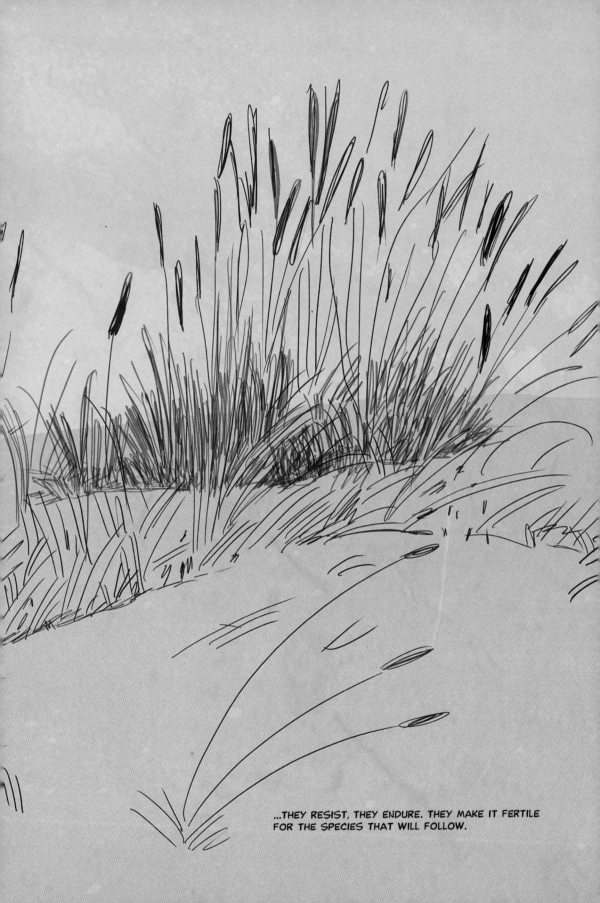

...THEY RESIST, THEY ENDURE. THEY MAKE IT FERTILE
FOR THE SPECIES THAT WILL FOLLOW.

GUERRILLA GIRLS

Storming the Male-Dominated Museum

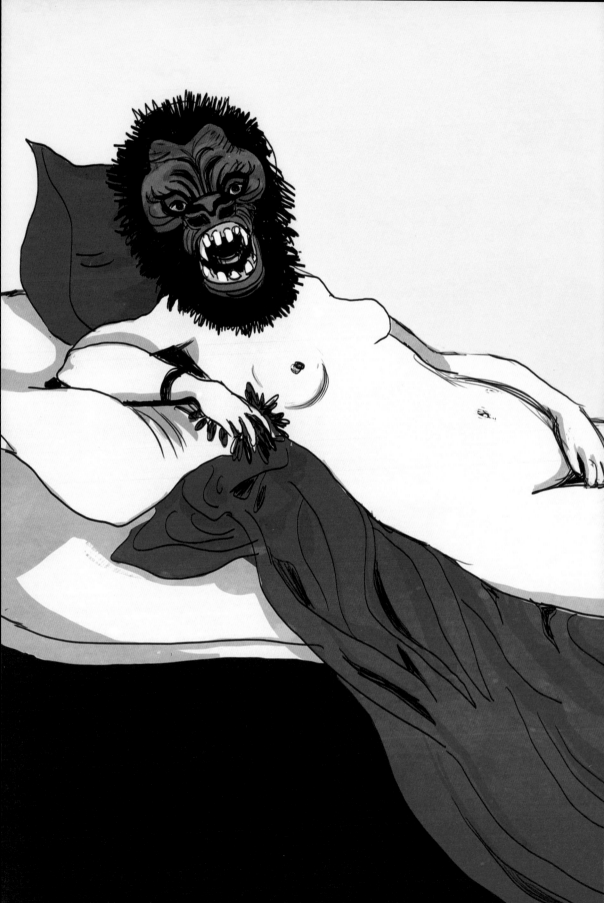

WE'RE FEMINIST ACTIVIST-ARTISTS.

THERE HAVE BEEN FIVE, TEN OR FIFTY-FIVE OF US OVER THE YEARS.
SOME FOR WEEKS, SOME FOR DECADES.

WE FIGHT DISCRIMINATION AND SUPPORT HUMAN RIGHTS FOR ALL
PEOPLE AND ALL GENDERS.

MUSEUMS ARE FILLED WITH FEMALE NUDES – BUT ONLY 5 PER CENT
OF ARTWORKS IN MUSEUMS ARE BY WOMEN.

WE HAVE DONE HUNDREDS OF PROJECTS ALL OVER THE WORLD.

GUERRILLA LIKE GORILLA: WE DON'T WANT A SPECIFIC IDENTITY;
WE'RE THE OUTRAGEOUS VOICE AWAKENING THE CONSCIENCE OF
THE ART WORLD.

WE DON'T JUST MAKE ACCUSATORY POSTERS. WE WANT TO
CHANGE PEOPLE'S MINDS, AND WE DO IT WITH A SENSE OF
HUMOUR TOO.

EVERYONE HAS THE RIGHT TO SPEAK THEIR MIND ANONYMOUSLY.
WHEN YOU WEAR A MASK, YOU CAN'T IMAGINE HOW MANY PARTS
OF YOURSELF CAN EXPRESS THEMSELVES FREELY.

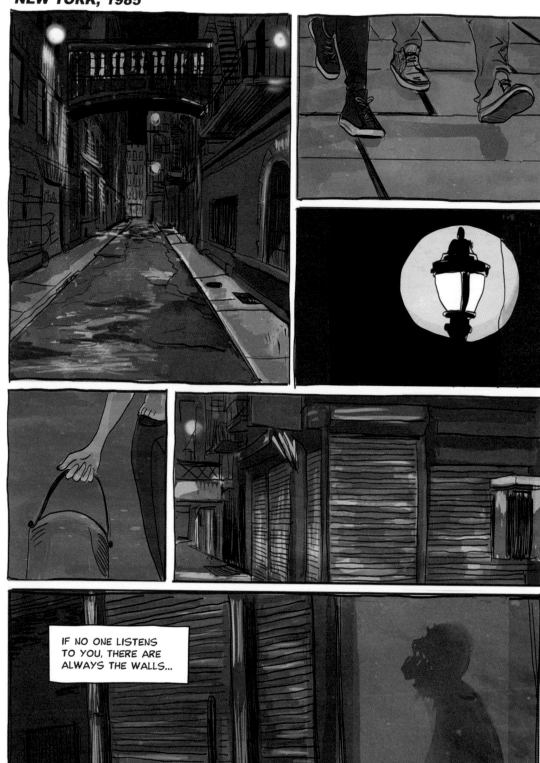

IF NO ONE LISTENS TO YOU, THERE ARE ALWAYS THE WALLS...

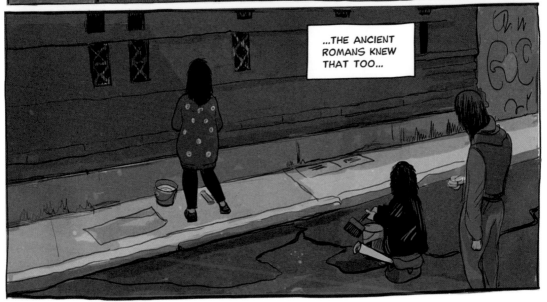

...THE ANCIENT ROMANS KNEW THAT TOO...

...AS WELL AS WORDS OF LOVE...

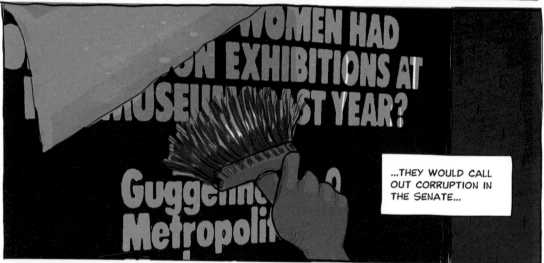

...THEY WOULD CALL OUT CORRUPTION IN THE SENATE...

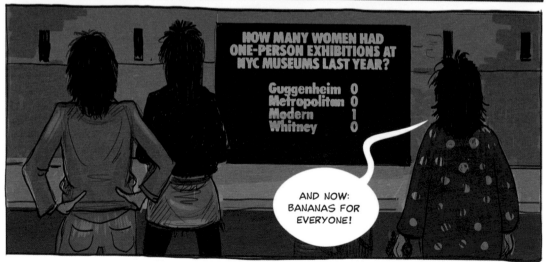

HOW MANY WOMEN HAD ONE-PERSON EXHIBITIONS AT NYC MUSEUMS LAST YEAR?

Guggenheim	0
Metropolitan	0
Modern	1
Whitney	0

WORDS FLY AWAY;
WRITING REMAINS

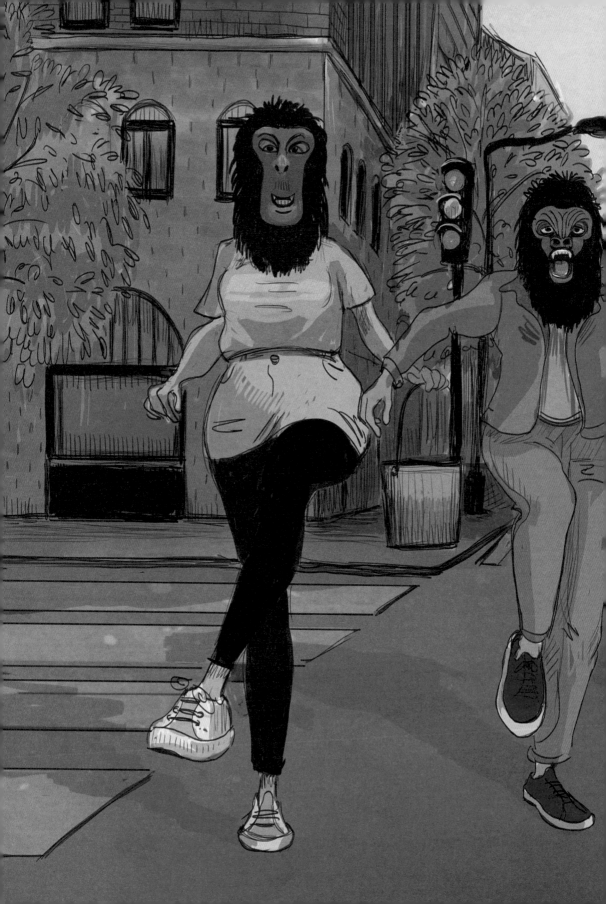

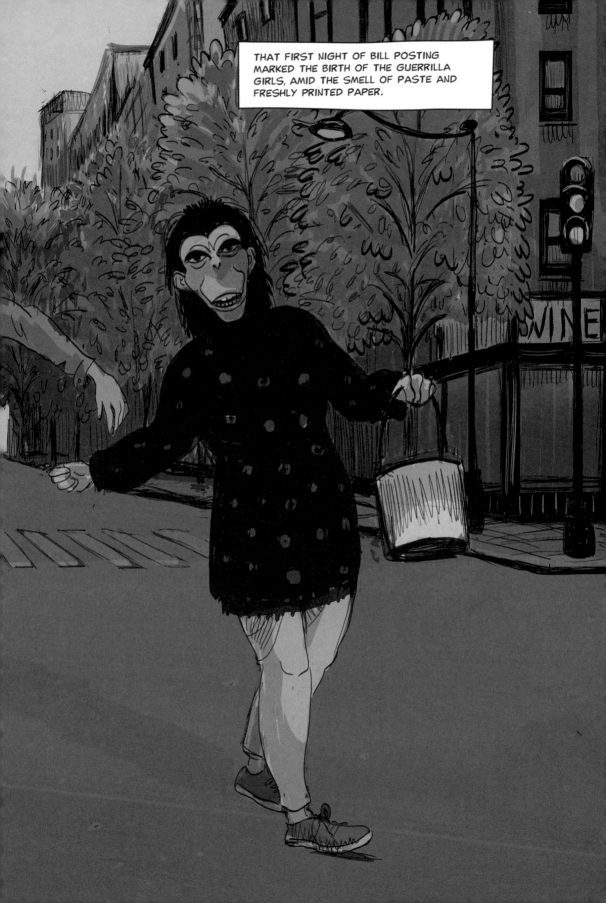

THAT FIRST NIGHT OF BILL POSTING MARKED THE BIRTH OF THE GUERRILLA GIRLS, AMID THE SMELL OF PASTE AND FRESHLY PRINTED PAPER.

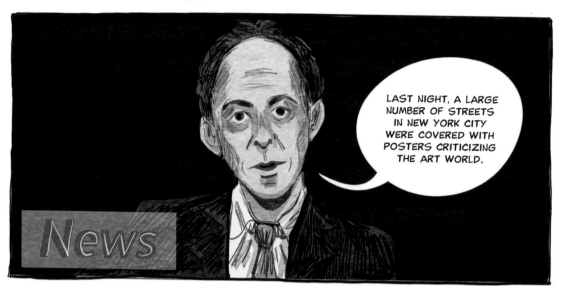

LAST NIGHT, A LARGE NUMBER OF STREETS IN NEW YORK CITY WERE COVERED WITH POSTERS CRITICIZING THE ART WORLD.

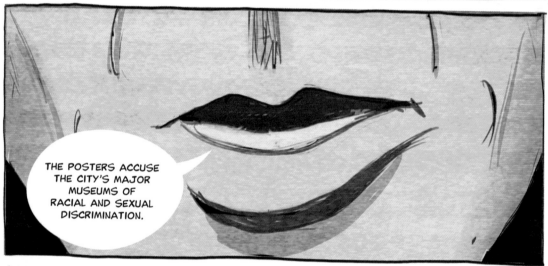

THE POSTERS ACCUSE THE CITY'S MAJOR MUSEUMS OF RACIAL AND SEXUAL DISCRIMINATION.

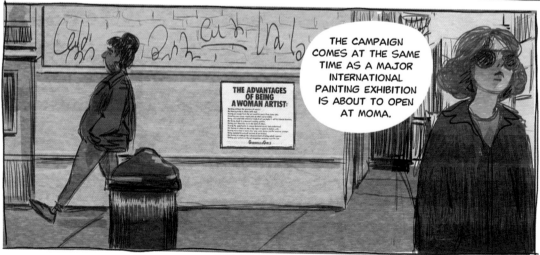

THE CAMPAIGN COMES AT THE SAME TIME AS A MAJOR INTERNATIONAL PAINTING EXHIBITION IS ABOUT TO OPEN AT MOMA.

THE FAMOUS MUSEUM IS CRITICIZED FOR THE FACT THAT OF THE 169 ARTISTS FEATURED, 100 PER CENT ARE WHITE, AND LESS THAN 10 PER CENT ARE WOMEN.

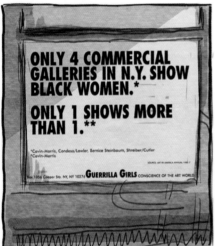

ONLY 4 COMMERCIAL GALLERIES IN N.Y. SHOW BLACK WOMEN.*

ONLY 1 SHOWS MORE THAN 1.**

*Cavin-Morris, Condeso/Lawler, Bernice Steinbaum, Shreiber/Cutler
*Cavin-Morris

SOURCE: ART IN AMERICA ANNUAL 1986/7

Box 1056 Cooper Stn. NY, NY 10276 GUERRILLA GIRLS CONSCIENCE OF THE ART WORLD

THESE CRITICS DON'T WRITE ENOUGH ABOUT WOMEN ARTISTS:

John Ashbery	*Robert Pincus-Witten
*Dore Ashton	*Peter Plagens
Kenneth Baker	Annelie Pohlen
Yves-Alain Bois	*Carter Ratcliff
*Edit de Ak	Vivien Raynor
Hilton kramer	John Russell
Donald Kuspit	Peter Schjeldahl
Gary Indiana	Roberta Smith
*Thomas Lawson	Valentine Tatransky
*Kim Levin	Calvin Tomkins
*Ida Panicelli	John Yau

RESPONSIBILITY FOR THE ACTION WAS CLAIMED BY A GROUP OF WOMEN ARTISTS WITH THE WARLIKE NAME...

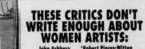

GUERRILLA GIRLS

CONSCIENCE OF THE ART WORLD

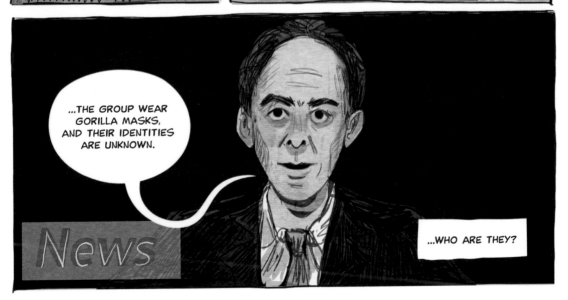

...THE GROUP WEAR GORILLA MASKS, AND THEIR IDENTITIES ARE UNKNOWN.

News

...WHO ARE THEY?

THEY'RE THE VOICE OF ALL WOMEN ARTISTS, PAST AND PRESENT, FROM THE LESSER-KNOWN TO THE MOST RENOWNED, AND THEY GO BY THE NAMES:

PAULA MODERSOHN-BECKER

EVA HESSE

KÄTHE KOLLWITZ

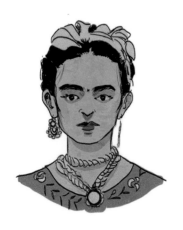

FRIDA KAHLO

ALMA WOODSEY THOMAS

GEORGIA O'KEEFFE

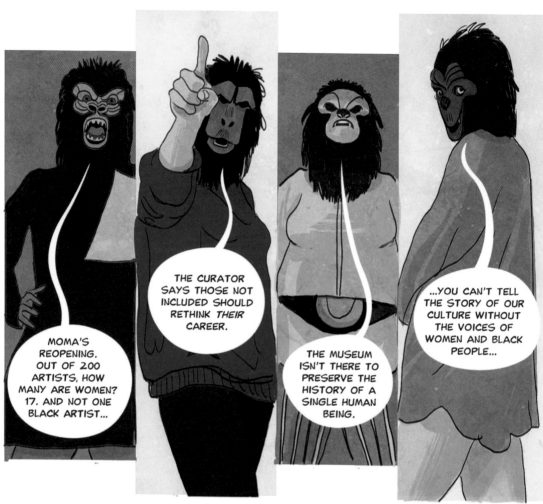

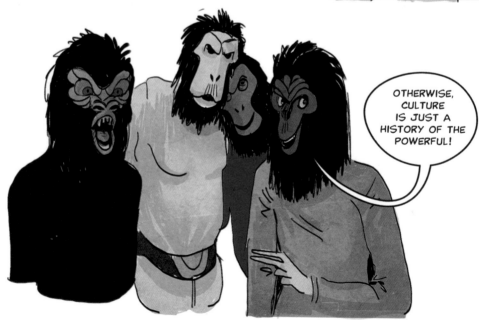

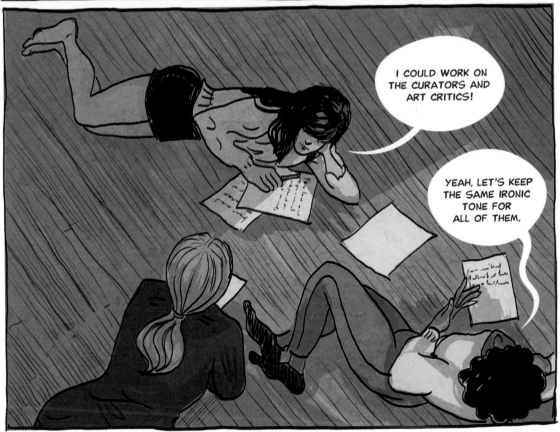

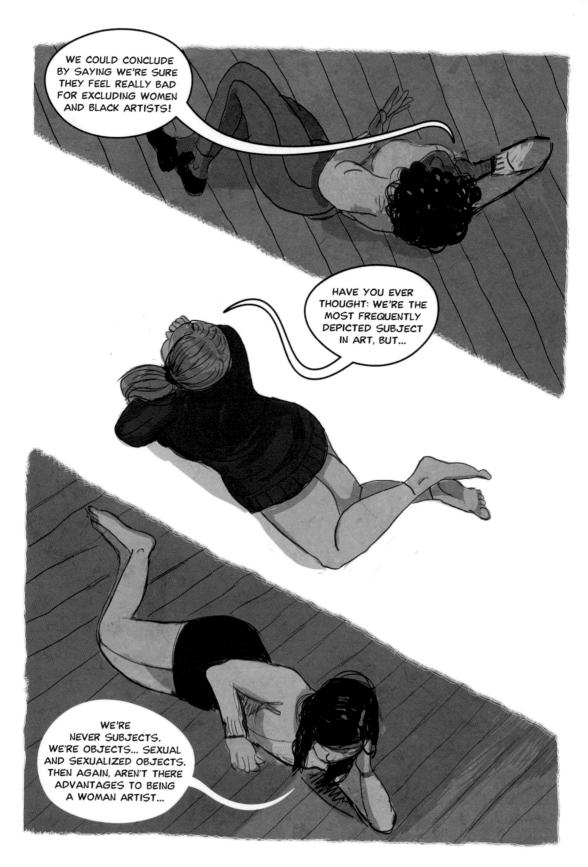

YOU CAN WORK WITHOUT THE PRESSURE OF SUCCESS!

YOU SEE YOUR IDEAS LIVE ON IN THE WORK OF OTHERS.

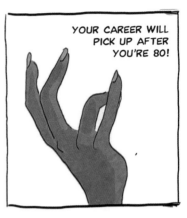

YOUR CAREER WILL PICK UP AFTER YOU'RE 80!

YOU CAN CHOOSE BETWEEN A CAREER AND MOTHERHOOD.

MO THER HOOD

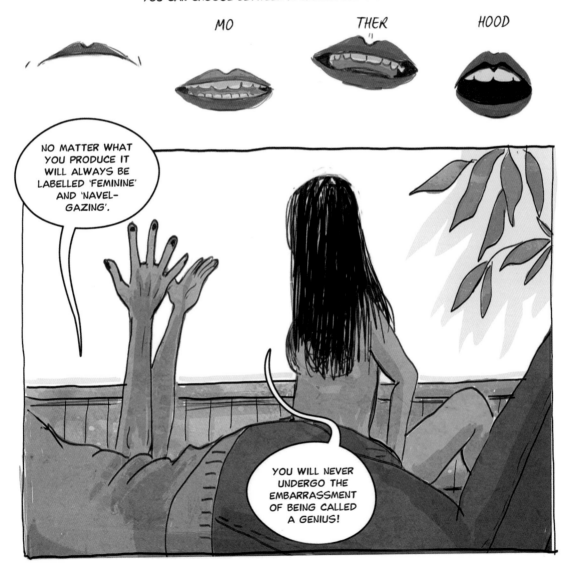

NO MATTER WHAT YOU PRODUCE IT WILL ALWAYS BE LABELLED 'FEMININE' AND 'NAVEL-GAZING'.

YOU WILL NEVER UNDERGO THE EMBARRASSMENT OF BEING CALLED A GENIUS!

THE STEREOTYPE NEEDS TO BE WORKED AROUND NOT WITH HYPOCRISY, BUT WITH QUESTIONS. JUST LIKE BARBARA KRUGER'S WORK DID, WHICH FORESHADOWED THE GUERILLAS' POSTERS.

I WORK WITH WORDS AND IMAGES SO THAT THEY ACT LIKE A MIRROR FOR THOSE WHO LOOK AT THEM.

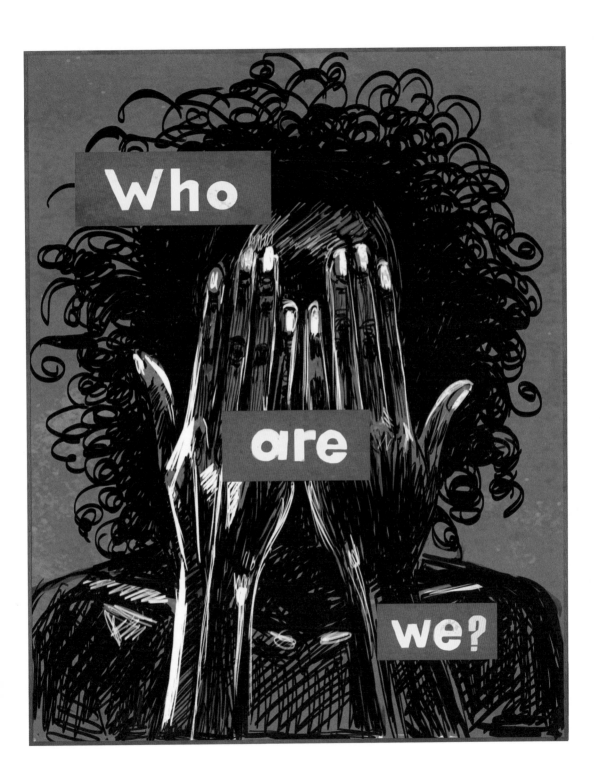

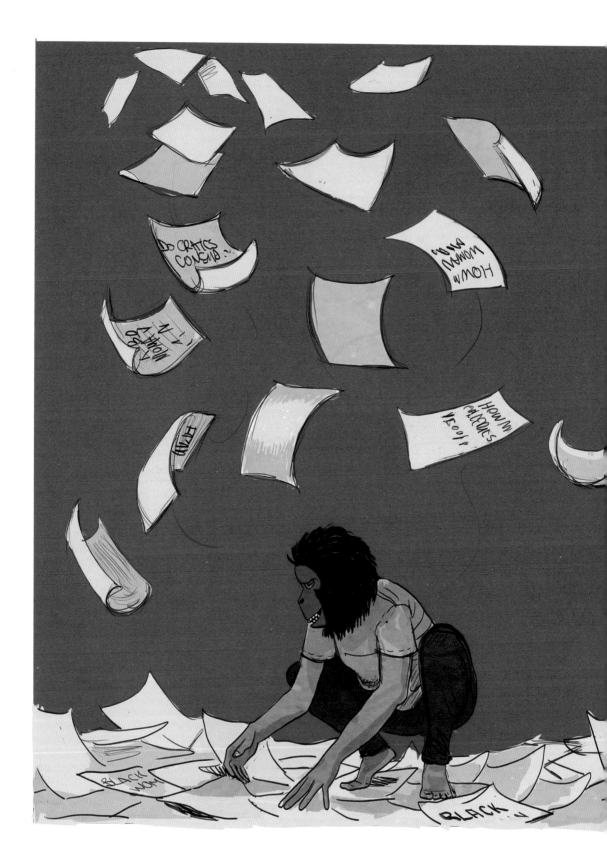

HYPOCRITE

IF YOU BUY ART AT BENEFITS FOR
LIBERAL CAUSES, BUT NEVER BUY ART
BY WOMEN OR ARTISTS OF COLOUR,
ASK YOURSELF WHO'S THE HYPOCRITE.

OVER THE YEARS THE GUERRILLAS
HAVE GROWN, BECOME MANY, AND
THEIR PROJECTS HAVE TRAVELLED
ALL OVER THE WORLD...

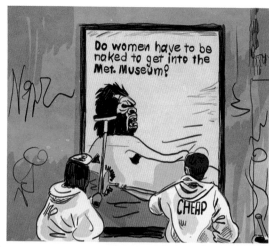

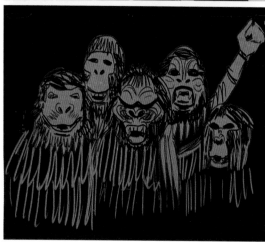

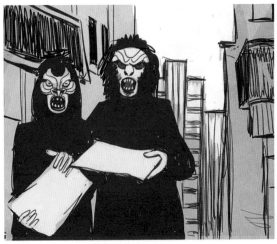

INCLUDING TO THE MUSEUMS
THEY HAD CRITICIZED.

THEY'RE EVERYWHERE...

...AND THEY COULD BE ANYONE.

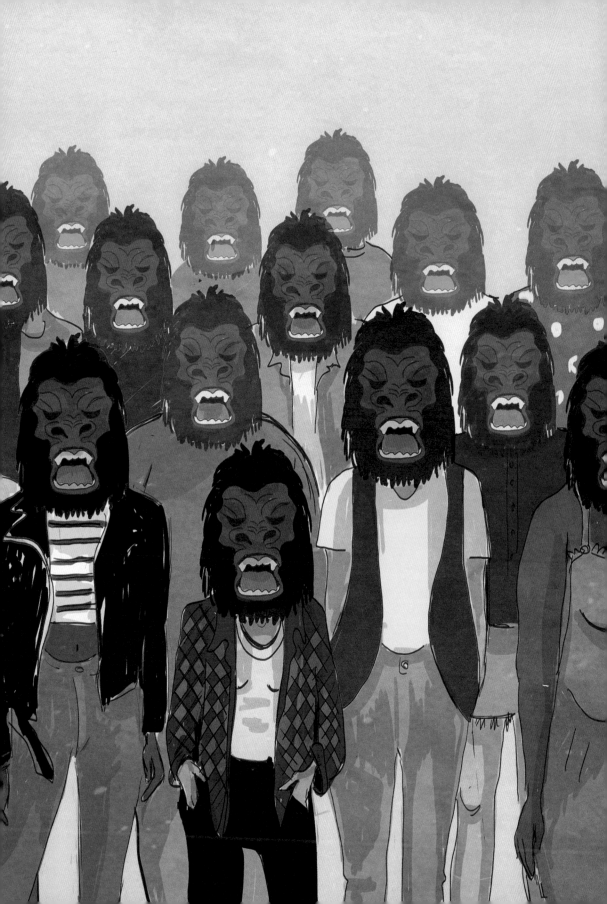

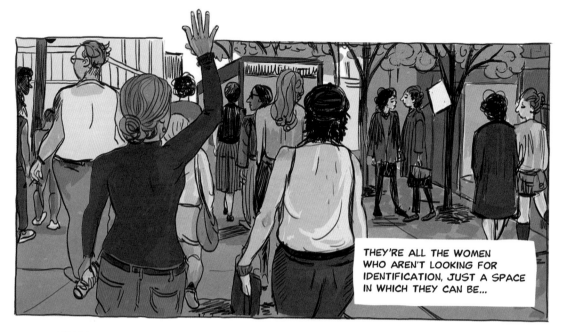

THEY'RE ALL THE WOMEN WHO AREN'T LOOKING FOR IDENTIFICATION, JUST A SPACE IN WHICH THEY CAN BE...

...AND WHO WONDER WHAT HAS BECOME OF ALL THE OTHER WOMEN AND ARTISTS LIKE ANA MENDIETA...

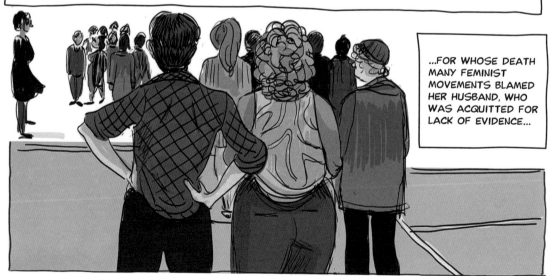

...FOR WHOSE DEATH MANY FEMINIST MOVEMENTS BLAMED HER HUSBAND, WHO WAS ACQUITTED FOR LACK OF EVIDENCE...

AND GUYS, THAT MEANS YOU, TOO. TIME TO MAN UP, WHETHER YOU'RE FEMALE, MALE, TRANS, ETC., AND SPEAK UP FOR WOMEN.

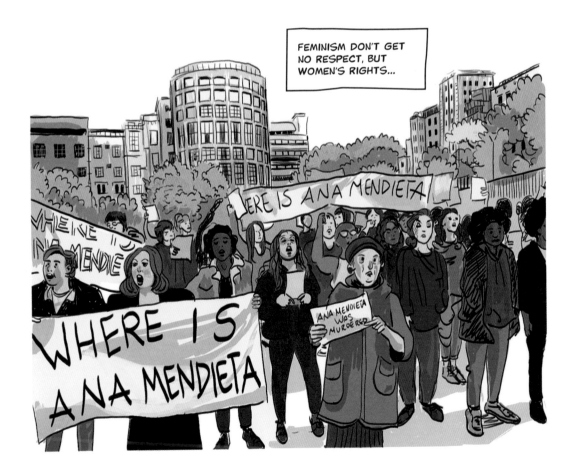

FEMINISM DON'T GET NO RESPECT, BUT WOMEN'S RIGHTS...

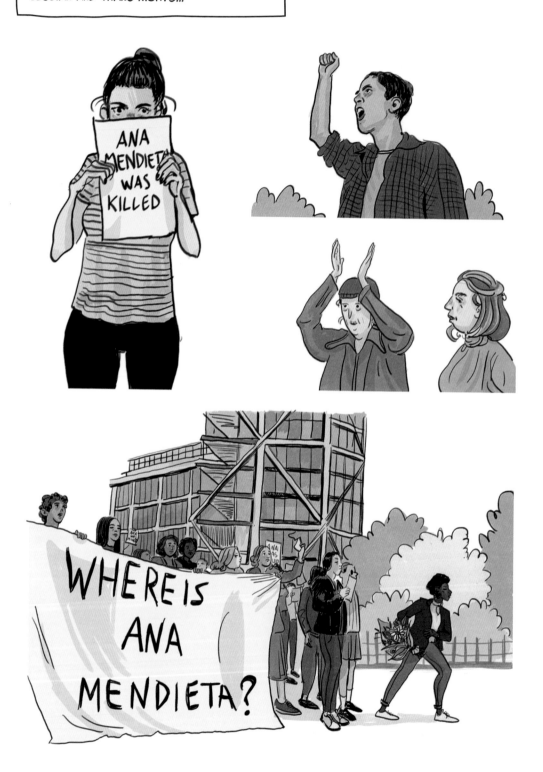

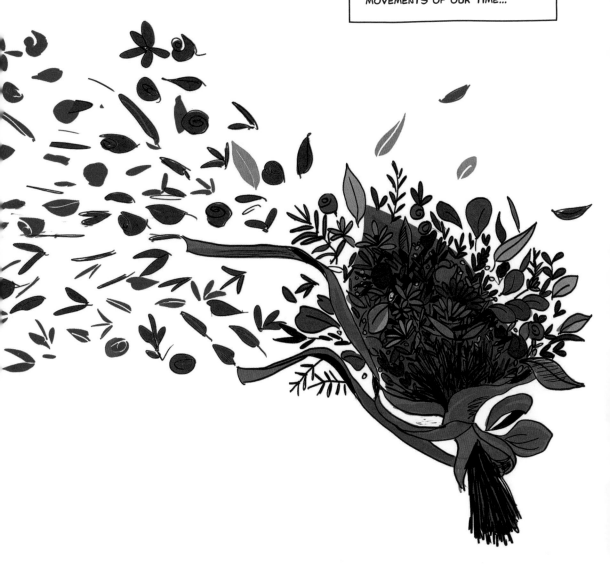

...ARE THE GREAT HUMAN RIGHTS
MOVEMENTS OF OUR TIME...

...ASK YOURSELF WHY SOMEONE
MIGHT WANT TO RESTRICT THEM.

CHARACTERS

MARINA ABRAMOVIĆ *(see page 34)*
(1946) Serbian artist, now an American citizen

The self-styled 'grandmother of performance art'. Since the early 1970s her performances have crossed the line between her own body and the viewer's, a relationship she explores through physical exhaustion, violence, oppression, abandonment and psychological collapse. Abramović's work reveals possibilities and breaks down borders, putting herself in the audience's hands with potentially extreme consequences.

ELEANOR ANTIN *(see page 87)*
(1935) American artist

Antin has been active since the early 1960s. Her work covers a variety of themes, but always through a feminist lens. From the 1970s to the 1990s she created a series of alter egos, each of a different gender, race, profession and age. Performing different identities enabled her to break down the very definitions that limit an individual's freedoms, creating the space for a more fluid understanding of identity.

EVA HESSE *(see page 112)*
(1936–1970) American sculptor of German origin

Hesse represented the post-minimalist movement of the 1960s, and stands out as one of the few women to be part of it, as well as for her immediate and humourous use of materials deemed unconventional at the time, such as fibreglass, plastic and latex. She never specifically labelled her work as feminist, but there's no doubt that the themes dear to feminism are present.

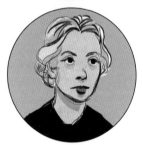

KÄTHE KOLLWITZ *(see page 112)*
(1867–1945) German sculptor and painter

Kollwitz was an expressionist artist and a member of the Berlin secessionist movement. Her work evolved over the years as she came under the influence of Bauhuas. As a pacifist and socialist, she was one of the first artists to take a clear stance on social issues. Her paintings and sculptures – but above all her prints, lithographs and woodcuts – depict war victims, the poor, the forgotten and left-behind.

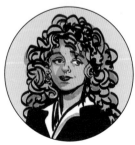

BARBARA KRUGER
(1945) American artist (see page 118)

After training as a designer, Kruger studied under the photographer Diane Arbus. She worked in fashion and publicity until she decided to use its codes to subvert the meanings behind the representation of women. With her black-and-white images, white fonts on a red background and provocative slogans, Kruger bursts into public space with works of damning cultural critique which address us directly, in a completely unmediated manner.

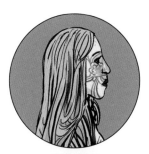

LYNN HERSHMAN LEESON *(see page 86)*
(1941) American film director and artist

Hershman Leeson worked on the influence of the social environment in the construction of female gender identity. From 1973 to 1978 she created and impersonated the persona of Roberta Breitmore, for whom she obtained a driving licence, credit cards and ID. She travelled around the United States for five years, living in Roberta's shoes. In 2011 she shot a documentary, *Women Art Revolution* in which she told the story of the feminist art movement in the United States.

PAULA MODERSOHN-BECKER *(see page 112)*
(1876–1907) German painter

A major exponent of early Expressionism, Modersohn-Becker produced some 750 paintings and 1,000 drawings, before dying prematurely at the age of 31 from postpartum complications. Her subjects are primarily women, specifically mothers with children, captured in intimate moments such as breastfeeding, or in ways almost entirely ignored by male paintings.

GEORGIA O'KEEFFE *(see page 113)*
(1887–1986) American painter

The mother of American modernism and the first woman to have a retrospective at MoMA. The success she achieved in the 1920s and the audacity of her paintings, where colour seems to dominate everything, influenced subsequent generations of female artists, thereby laying – perhaps unwittingly – the foundations for the development of feminist art.

YOKO ONO *(see page 11)*
(1933) Japanese artist

As well as a human rights activist, Ono was among the early members of the avant-garde Fluxus movement, and one of the forerunners of performance art and conceptual art. Her work ranges from music to performance, writing, experimental cinema and installation.

HOWARDENA PINDELL *(see page 65)*
(1943) African-American artist

Pindell makes use of a variety of artistic techniques and genres, adapting them to the common conceptual framework of every piece, which is embodied in the critical gaze she brings to a series of recurring themes: feminism, racism, slavery and social injustice.

ADRIAN PIPER *(see page 86)*
(1948) African-American concept artist and philosopher

Piper's stated aim is to undermine racist views, helping people to face up to them. She achieves this through work that targets the root of the problem and speaks forcefully about race, identity, gender and social background, as well as the controversial issue of passing.

BETYE SAAR *(see page 56)*
(1926) African-American artist

In the 1970s Saar was involved in the Black Arts Movement, which also included Audre Lorde and Nikki Giovanni. Her work is characterized by its powerful political impact and for combating the prevailing culture's stereotypes of women and Black people.

CAROLEE SCHNEEMANN *(see page 35)*
(1939–2019) American artist

Schneemann was associated with various artistic movements (Fluxus, Neodada, Body Art). Between the 1960s and 1970s she created performance and video work in which she enacted, often in a brutal manner, an erotic and genital reappropriation of the female body. The power and sexual charge of her actions called into question the taboos surrounding nudity, sexuality and gender representation.

MIRIAM SCHAPIRO *(see page 30)*
(1923–2015) Canadian artist

One of the pioneers of feminist art along with Judy Chicago, Schapiro took part in the collective project *Womanhouse*. She was a founder of the Pattern and Decoration artistic movement, and her practice embraced both art and craftsmanship, revolutionizing the significance of objects, symbols and housework that were traditionally associated with women.

CINDY SHERMAN *(see page 87)*
(1954) American artist

Her photographic works from the 1970s reflect on female iconography in relation to the stereotypical male gaze. Sherman staged self-portraits of herself which recreated film stills and female beauty icons, ritualizing both male and female gender roles. This reappropriation of identity is experienced through the intimate relationship between Sherman as both the subject, and author, of the image.

NANCY SPERO *(see page 63)*
(1926–2009) American artist

Spero is considered a pioneer of feminist art. In 1972 she was one of the founders of A.I.R. Gallery in New York, created with the aim of supporting female artists. Her artistic output challenged Western privilege and patriarchy. She was a friend of Ana Mendieta's, and following the Cuban artist's death created a series of works in tribute to her.

ALMA WOODSEY THOMAS *(see page 113)*
(1891–1978) African-American expressionist painter

Woodsey Thomas dreamed of becoming an architect, but as it was not considered a suitable job for women she turned to teaching. In the 1960s, following her retirement, she finally managed to devote herself entirely to painting. Critics have recently rediscovered her work, belatedly recognizing its contribution to American abstractionism following decades of being unfairly underrated.

BIBLIOGRAPHY

- James Baldwin, *Notes of a Native Son* (Boston, Beacon Press, 2012)

- Jane Blocker, *Where Is Ana Mendieta?: Identity, Performativity, and Exile* (North Carolina, Duke University Press Books, 1999)

- Judy Chicago, *Through the Flower: My Struggle as a Woman Artist* (Bloomington, iUniverse, 1984)

- Emanuela De Cecco, Gianni Romano, *Contemporaries: paths and poetics of female artists from the 1980s to the present* (Milan, Postmediabooks, 2002)

- Manuela De Leonardis, *The blood of women. Traces of red on white cloth* (Milan, Postmediabooks, 2019)

- Helena Reckitt and Peggy Phelan, *Art and Feminism* (London, Phaidon Press, 2005)

- Faith Ringgold, *We Flew over the Bridge: The Memoirs of Faith Ringgold* (North Carolina, Duke University Press Books, 1995)

DOCUMENTARIES

- *Women Art Revolution*, dir. Lynn Hershman Leeson, 2010

WORKS CITED AND COPYRIGHT INFORMATION

ACKNOWLEDGEMENTS AND DEDICATIONS

EVA ROSSETTI

Thanks to Balthazar and Valentina for inviting me onto the project and welcoming me so enthusiastically. Thanks also to Sandra, Marco and Studio RAM for their invaluable work.

To my girlfriends, all beautiful, all different.

VALENTINA GRANDE

Thanks to Balthazar for allowing me to grow professionally, and Eva for bringing beauty and harmony to every board; thanks also to Marco, Sandra and Studio RAM for their exceptional professionalism.

My thanks to Andrea Carboni for his help with the translations, Elisa Coco for her critical reading, as well as Cheap Festival and the feminist artistic duo TO\LET, which appear in one of this book's pages. Thank you to Simona Brighetti and Virginia Gentilini for their help with the Bibliography, and to the Guerrilla Girls for allowing us to use their works, and indeed the quotation with which we end the book.

If I can now take part in a feminist meeting and feel like I'm a part of it, but above all write a book like this one, I owe it to Valentina Pinza: I can never thank you enough.

To the Italian Women's Library at the Bologna Women's Centre, which safeguards our past, our present and our future.

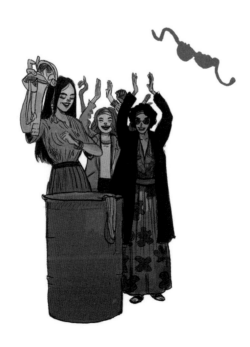